Between Cultures: Children of Immigrants in America

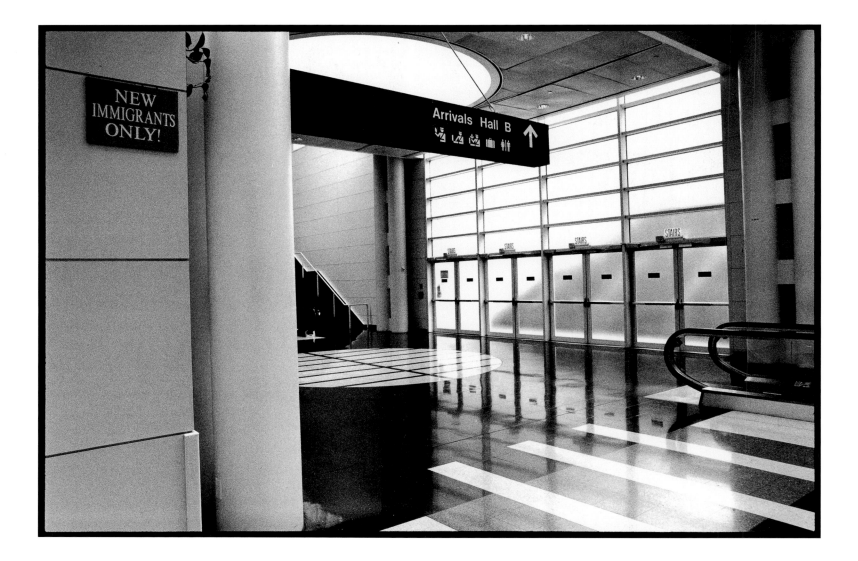

Between Cultures

Children of Immigrants in America

by Gina J. Grillo

with a conclusion by Leo Schelbert

CENTER FOR
AMERICAN
PLACES

Santa Fe, New Mexico, and Staunton, Virginia

in association with

Columbia
COLLEGE CHICAGO | *C*

PUBLISHER'S NOTES: *Between Cultures: Children of Immigrants in America* is the fourth volume in the series *Center Books on Chicago and Environs*, created and directed by the Center for American Places, with the generous financial assistance of the Graham Foundation for Advanced Studies in the Fine Arts. The book was issued in an edition of 3,000 hardcover copies, and was brought to publication with the generous support of Columbia College Chicago, the Dolores Kohl Education Foundation, Jack Jaffe, Susan Soble, and Susan Youdovin, for which the publisher is most grateful. The Center also acknowledges the tremendous support it received from Bob Thall, chairman of the photography department at Columbia College Chicago, in making this book possible. The publication of *Between Cultures* coincides with a solo exhibition of Ms. Grillo's photographs at the Ellis Island Immigration History Museum and Statue of Liberty Monument in New York City, February 14–May 31, 2004. For more information about the Center for American Places and the publication of *Between Cultures: Children of Immigrants in America*, please see page 122.

Frontispiece: The International Terminal Arrivals area at O'Hare International Airport, 1998, where so many new immigrants enter the United States of America.

Published 2004. First edition.
Printed in Singapore on acid-free paper.

Center for American Places, Inc.
P.O. Box 23225
Santa Fe, New Mexico 87502, U.S.A.
www.americanplaces.org

Distributed by the University of Chicago Press
www.press.uchicago.edu

9 8 7 6 5 4 3 2 1

Library of Congress Cataloging-in-Publication Data is available from the publisher upon request.

ISBN 1-930066-16-3

For my mother, Elisa,
in memory of my father, Michael,
and in honor of my grandparents,
Diamonte and Olga, Virginia and Joseph,
who were willing to risk everything
to come to America.

Contents

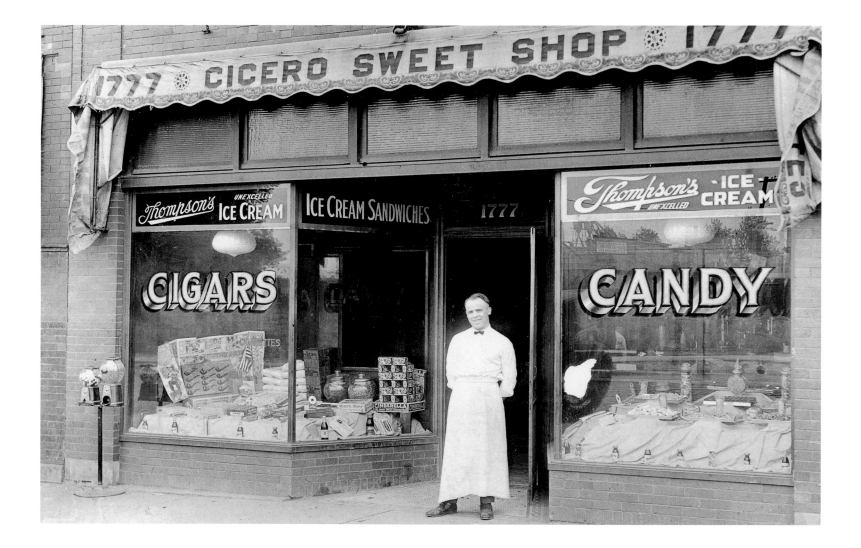

The author's grandfather, Diamonte, in front of his store
at the corner of Cicero and Grand, in Chicago, c. 1915–1920

The Migrant Spirit

One's past is what one is.
—*Oscar Wilde*

I GREW UP WITH A LONGING for my Italian heritage, to know my grandparents who had come to America from Italy long before I was born. To me, Italy was a place of simmering tomato sauces, a place of lush hills, lemon trees, and olive groves with an Adriatic view. Their immigrant stories were told to me the way one receives a prayer, and part of my history was made in their repeating. These visual scenes started out as flashes of light, taking shape in my mind's eye as stories.

My great grandmother, Elisa, crossed the Atlantic Ocean holding her infant daughter on her way to America, a country where her young husband had died of pneumonia six months earlier. My grandfather, Diamonte (Diamond), came to America with his brother when he was sixteen years old, having herded sheep on a hillside in Umbria until his departure for the United States. Eventually he made his way to Chicago, to the corner of Grand and Cicero, where he opened his first business (see page viii). My grandmother, Olga, arrived at Ellis Island as a child, and spent much of her youth dipping O'Henry bars into chocolate at a nearby factory before marrying Diamonte and building their lives and their family around a thriving restaurant business.

As a kid growing up in the 1960s I lived in a North Shore suburb of Chicago in a house my father, an architect, designed. Our world was virtually a world away from our Italian past. Early on I was fascinated with old family photographs and obsessed with the notion that our family history

would be lost in the old cardboard boxes filled with images that my mother kept underneath her bed. You might say I heard a calling. A slow, faint, consistent calling to uncover and sift through those dusty boxes, to study the worthy treasures, believing this act might begin our steps toward understanding our family history and somehow bring us closer to ourselves. The smell of cardboard-faded sepia, the yellowed glue at the corners that once held a hand-colored portrait behind a studio mat. I felt a pull towards this photographic world that seemed natural and exotic at the same time. My exploration was fueled by my longing to uncover the mystery and purpose of the lives that came before my own. At some point I think I just dubbed myself the guardian of our family's past, "the preserver of the intangible cultural property" we had haphazardly stored away.

I didn't come to photography early in my life. In fact it wasn't until my twenties that I realized I had been imagining photographs as a child long before I ever owned a camera. When I was alone, and sometimes during visits to the city with friends, I can remember stopping to take in certain unexpected scenes and saying out loud,

"What a beautiful photograph that would make." I consoled my creative urge with the notion that, when I could afford to, I would certainly invest in some decent camera equipment. But this seemed a far and distant concern. Mostly I just pictured scenes in my head, like the stories of my grandparents' struggle, as a reminder of where I came from, always there to reexamine whenever my own life seemed wayward or lurching.

As a young woman, I worked in development and fundraising for the Chicago Council on Foreign Relations, where I was encouraged to study my own ethnic heritage and the Italian language, and to visit Italy for the first time. Exposed to a broad array of experts on international relations and cultural affairs, I was privy to many views on immigration policy, and often frustrated with those who contested the rights of "new" immigrants to enter our country. During this period I also started photographing on work-related trips to Europe, Asia, and the South Pacific, taking photographs for our organizational newsletter, using "the Council Camera" (a Nikon One-Touch). Until one day when a co-worker generously left her husband's long-unused 35-mm

camera on my desk. I began studying photography on Saturdays at the School of the Art Institute of Chicago, literally across the street from my Council office. This provided my first formal introduction to the medium of photography and began a series of events that would transform my creative life. My connection to photography seemed to me almost magical-long awaited, and, once discovered, it gave me a depth of purpose I was never aware of before.

Eventually I quit my job at the Council to pursue an M.F.A. in photography at Columbia College Chicago. As a graduate student, I worked for the Museum of Contemporary Photography, which greatly enhanced my visual education. Henri Cartier-Bresson's writings on photography defined my initial jubilation with the craft of photography, "to put one's head, one's eye, and one's heart on the same axis. To take photographs is to hold one's breath when all faculties converge in the face of a fleeing reality."*

*This text was first published in the *Aperture History of Photography Series*, *Volume 1*, copyright 1976 by Henri Cartier–Bresson, Aperture, Inc., and Robert Delpire.

As my photographic inspirations grew, I found great interest in the use of "magic realism" in documentary work, as practiced by photographers such as Luiz Gonzalez Palma and Pedro Meyer. This was reality re-expressed, as in the mythological manufacturing of Keith Carter's work along the Mississippi River. I also developed great respect for the historic contributions of Jacob Riis, Lewis Hine, and the lesser-known immigration inspector Augustus Sherman, who endlessly photographed immigrant arrivals at Ellis Island during our country's peak immigration years. I felt a kinship to this humanist documentary approach, and related to their exuberant devotion to subject matter.

When I began the *Between Cultures* project in 1995, I didn't know where to start. My subject of immigration seemed so large and I certainly had no idea that this photographic work could take me back to the beginning of my citizenship and the history of citizenship in our country. Out of sheer desperation, and on the good advice of a fellow photographer, I decided to start where new immigrants begin their lives in Chicago. I went to photograph the lines outside the Immigration and

Naturalization Service (INS) office on Jackson Boulevard—the lines converged at about 7:00 a.m. in the middle of winter, as crowds of new immigrants waited to be processed. Months later, I heard that Mayor Richard M. Daley was hosting a swearing-in ceremony for new citizens in Grant Park, and I thought, "That's where I ought to be." This led to my interest in citizenship ceremonies, and quickly I learned that I had to go through several channels to gain access to these events, first writing a letter to one judge requesting permission and describing my intent. I couldn't have known at the time that my path toward the subject of immigration would be such a crucial learning experience. Until I photographed my first ceremony, I had never seen the Oath of Citizenship, a moving, patriotic document that most Americans have never had the chance to read (see pages 114–115). While photographing ceremonies, I met several immigrant families who sometimes invited me to their homes.

During this time I was also developing an interest in ethnic communities in Chicago, how the facade of a neighborhood can define or reveal its level of diversity—and how fleeting that is. I started to realize that the street in Chinatown I was photographing today could perhaps become unrecognizable fifty or one hundred years from now. Photographing in ethnic neighborhoods revealed a wealth of image-making opportunities for me. I wanted to make photographs that would reflect what one could see on the streets, the level of diversity in a neighborhood or at a public cultural celebration downtown.

Years into the project the INS learned of my photographic work and invited me to photograph new immigrant arrivals coming into the O'Hare International Airport. This was a turning point, as it opened up a whole new aspect of the immigrant experience. I was given excellent access and flexibility in scheduling my shooting time any day of the week. I would wait in the "new immigrant arrivals" section for the planes to come in. This was a tedious endeavor, and required at least eight-hour stints to get the most out of my shooting efforts, as it was impossible to determine how many immigrants would arrive in Chicago on any given day, and from where they would come.

When a plane with new immigrants would arrive, the passengers—many of whom had been traveling for the good part of twenty-four hours—would enter the terminal, coming directly to the new arrivals section. Then, I would approach them with my camera. Quite a challenge, but, often with the help of the children who spoke some English, I would talk with these families and, if they were willing, photograph their arrival. When my own family arrived in Chicago around 1910, Italians were one of the largest immigrant groups. This is not the case today, as most of the immigrants I met were from India, China, Poland, and Russia. Through this process I began to feel a historic significance in my work, and this was a remarkable revelation.

When I started *Between Cultures*, I didn't realize the gift of stepping back to look at my own life and to examine the meaning of the immigrant journey. Since the immigrants in my own family were no longer living, I turned to the new immigrant families around me, so that I could trail backwards to reconstruct part of my own family's history. I began with a wishful certainty that the lives of new U.S. immigrants must be driven by the same motivations as my grandparents had. I imagined the ghosts of my grandparents prodding me on, certain of their assurance that this subject was worthy of my exploration. If the expression *"It is loneliness that makes one free enough to travel"* is true, then I was surely lonely for my grandparents, and for my roots, so much so that my photographic journey seemed as unquestionable to me as their coming to America.

Between Cultures: Children of Immigrants in America

Journey: An act of travel or passage from one place to another; to travel over or through. The journey from childhood through adolescence to maturity.

Arrival: An act of reaching a destination; to make an appearance. The attainment of an end or state; success.

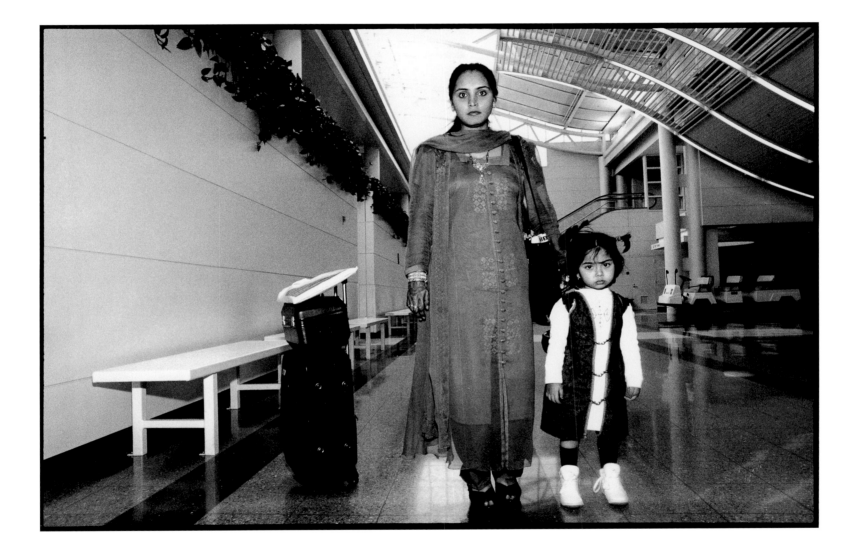

Mother and daughter from India
O'Hare International Airport, 2000

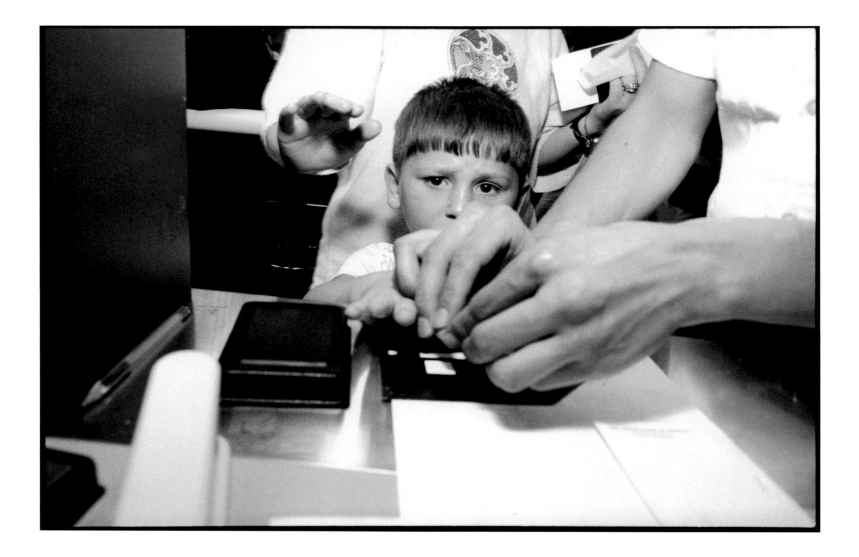

Boy from Albania is fingerprinted upon arrival
O'Hare International Airport, 1999

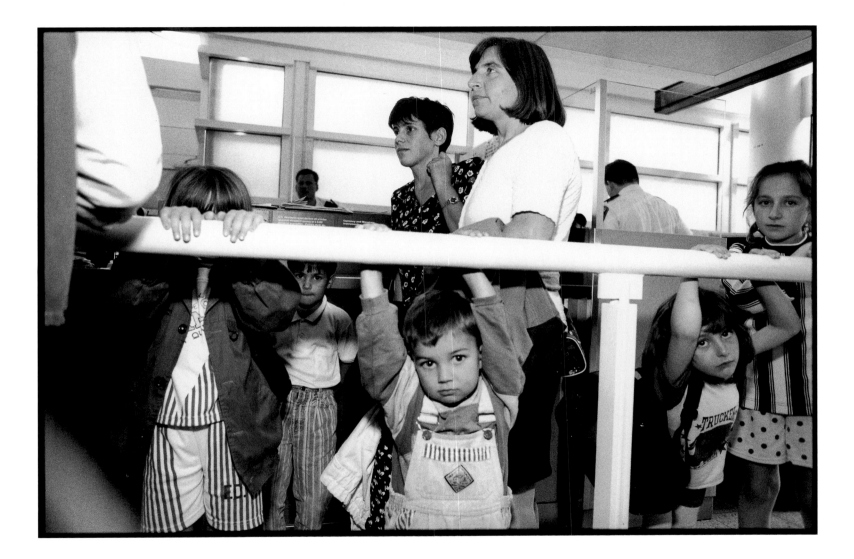

Families from Bosnia wait to be processed
O'Hare International Airport, 1999

When I left my country Vietnam I didn't know that I would probably never come back again. I was just ten years old. I knew my life would begin from this moment.

Ngoe Nguyen
Vietnam

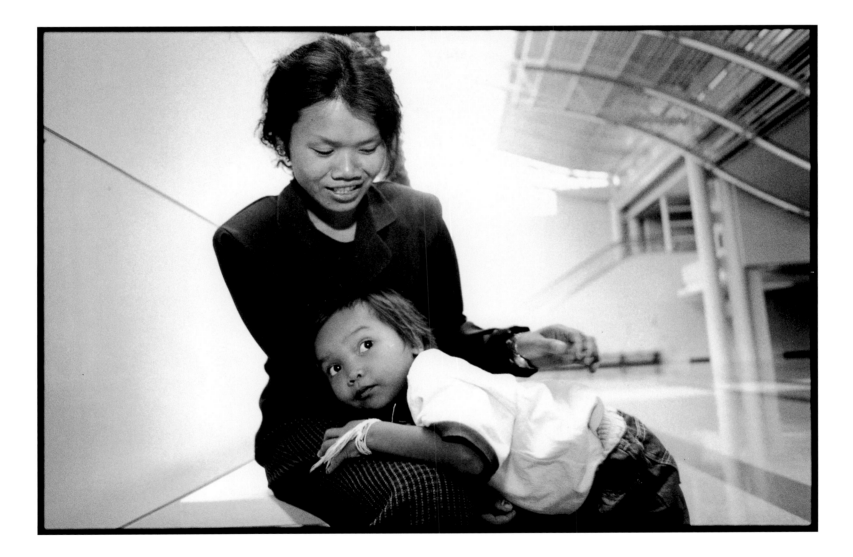

Mother and daughter from Thailand
O'Hare International Airport, 1998

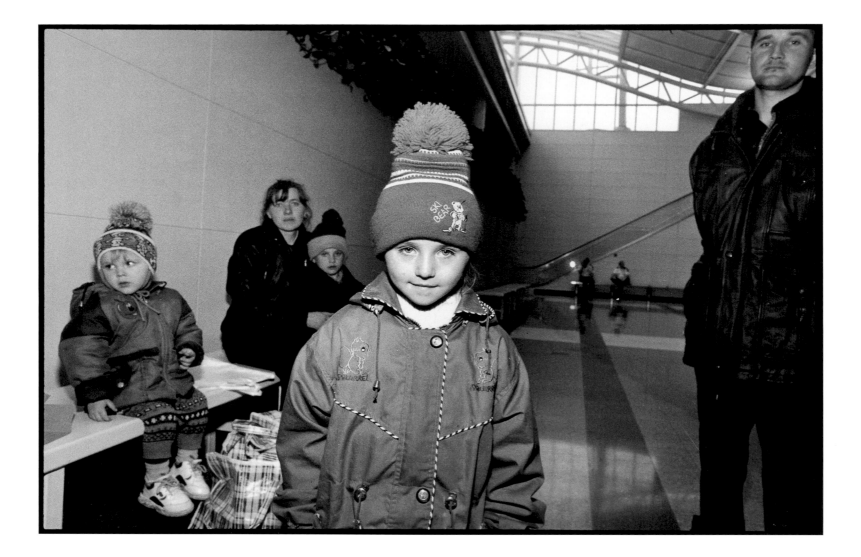

Family from Bosnia
O'Hare International Airport, 2000

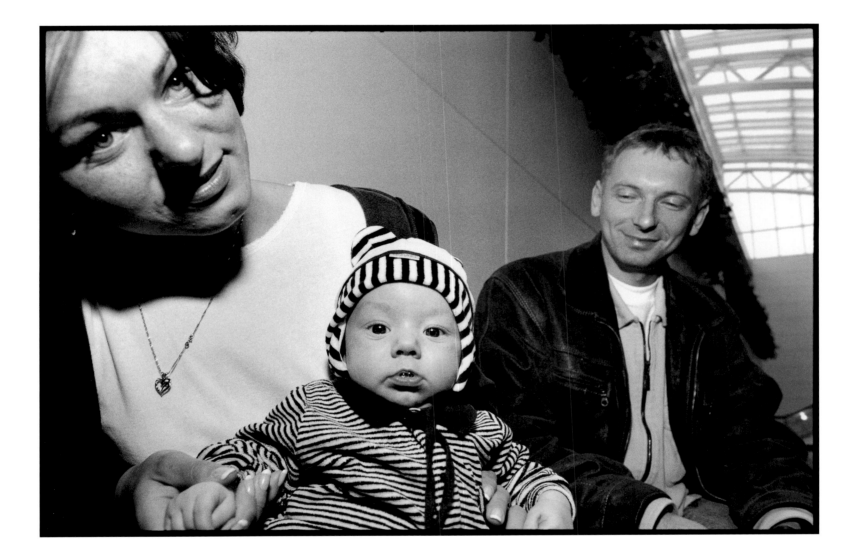

Family from Lithuania
O'Hare International Airport, 1998

If we stayed in Bosnia we would have probably been killed. Although no one can predict the future, just imagine a seven-year-old child wondering if he would be killed the next day or spared in this world we call home.

Denis Tuzinoviz
Bosnia

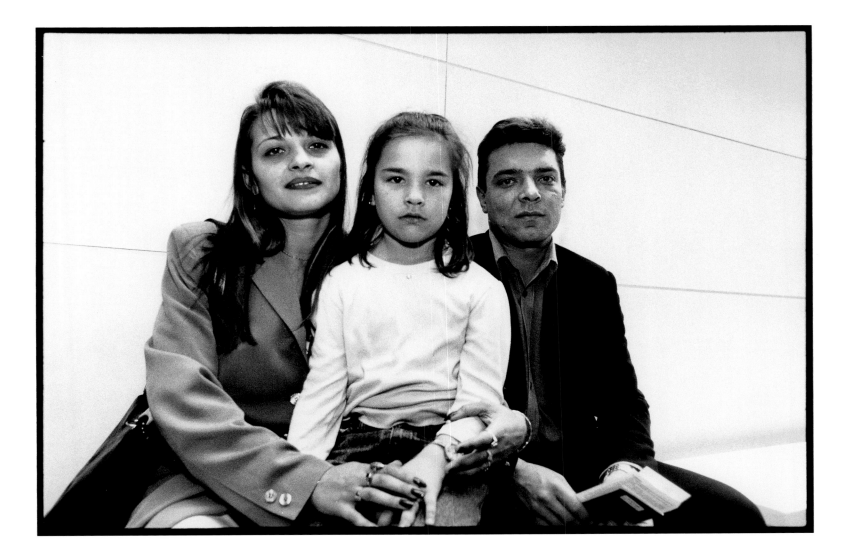

Family from Poland
O'Hare International Airport, 2000

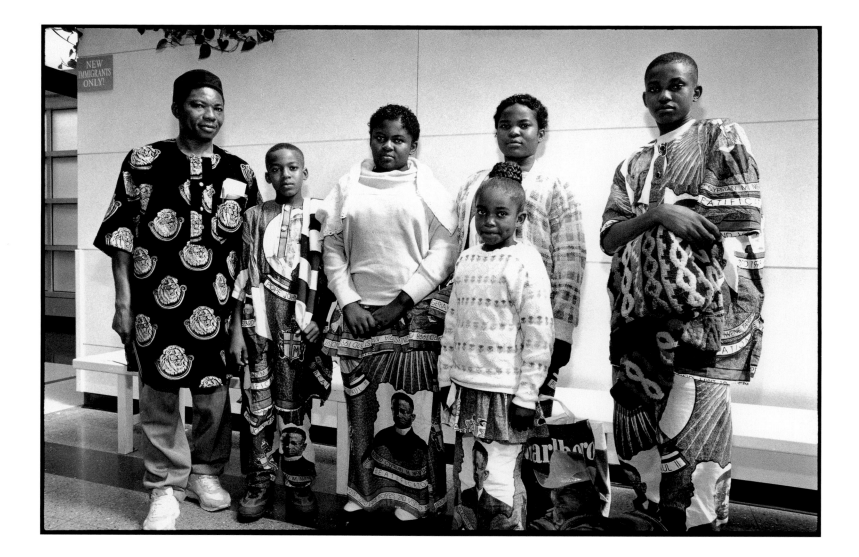

Family from Nigeria
O'Hare International Airport, 1998

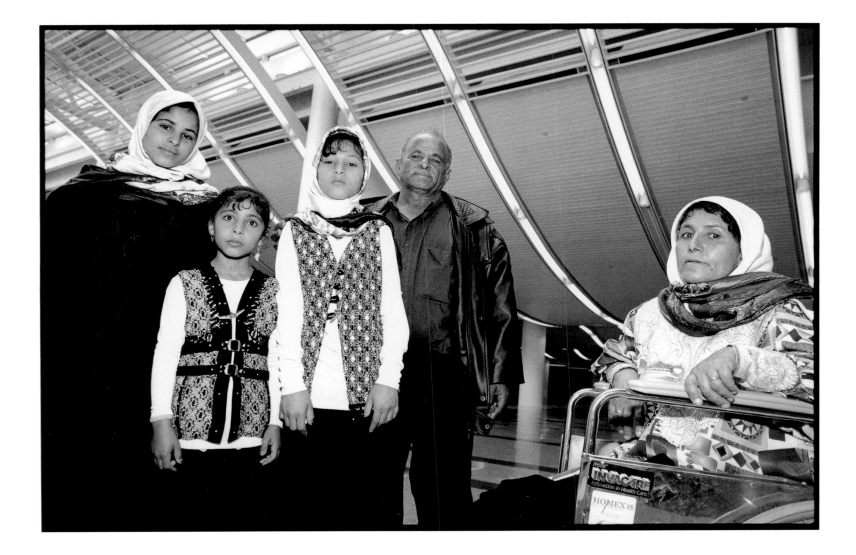

Family from Yemen
O'Hare International Airport, 1998

On the plane it was thrilling, but I did not want to go. Something just told me you've got to do this; it will help you when you grow up. When we arrived in Chicago we were on the highway—sun shining, daylight glittering—and we stopped to get some hamburgers and some drinks. That was my first time tasting hamburgers and my first time having this kind of experience. This was our first time in Chicago and I was happy, my mom was happy too. My sister was crazy happy.

Nimley Tabue
Liberia

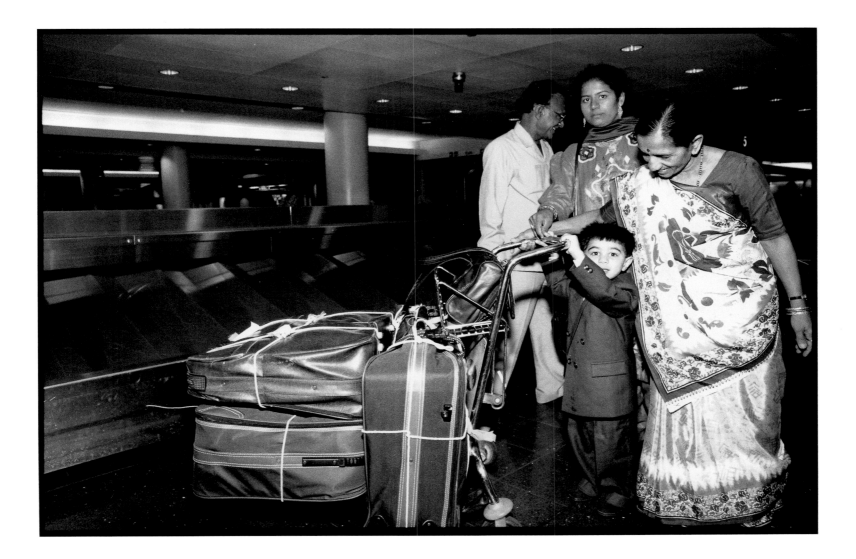

Retrieving the luggage
O'Hare International Airport, 1998

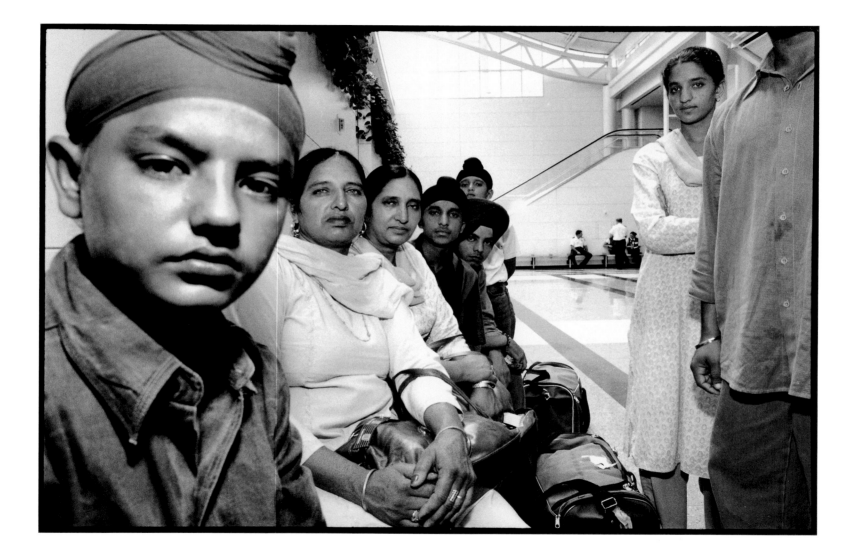

Two families from Pakistan
O'Hare International Airport, 1998

It wasn't by magic that I came to the United States; it was through an organization for immigrants. Togo was being ruled by a tyrant. His malevolent ways caused the people to rebel. This predicament made Togo a tumultuous country to live in. My father was concerned for his family's future, and decided to move to another country. The only thing we knew about Chicago was that it was the city of Michael Jordan and the Bulls, and it had the world's busiest airport, O'Hare.

Alonko Bruce
Togo

Identity: The collective aspect of the set of characteristics by which a thing is definitely recognizable or known. The set of characteristics by which an individual is recognizable as part of a group. The quality or condition of being the same as something else.

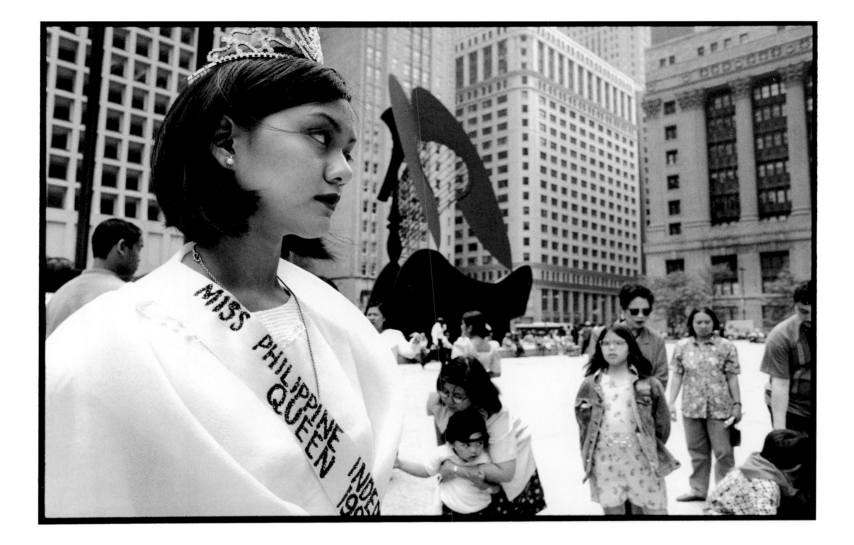

Miss Philippine Independence Day Queen
Downtown Chicago, 1997

America has anything we need: technology, goods. At least one person from every nation lives here. People immigrate to America because they know it's a land of freedom and a better life. I see America as a land of opportunities.

Tamara Farnik
Poland

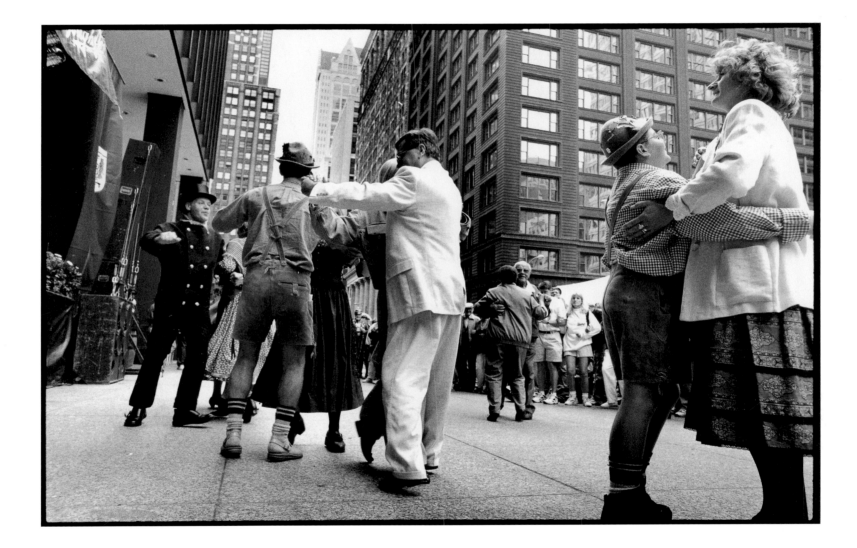

Oktoberfest
Downtown Chicago, 1996

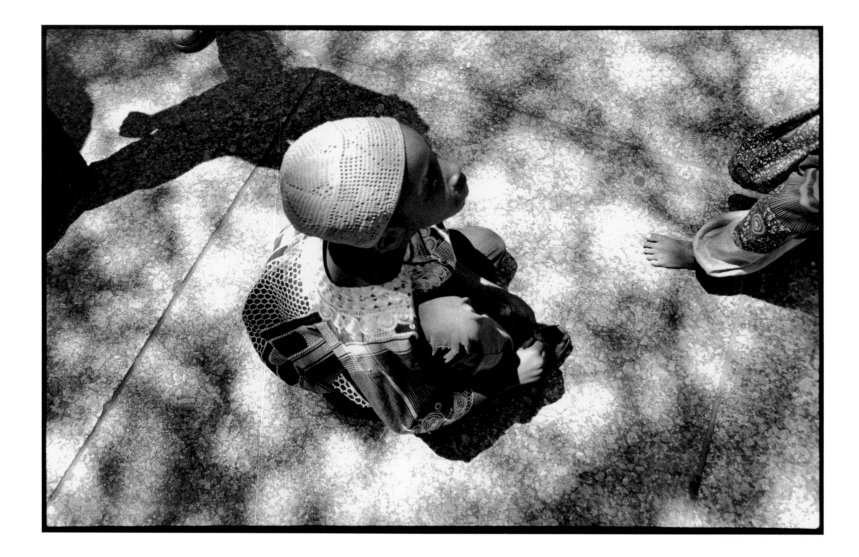

Ethnic Heritage parade
Downtown Chicago, 1996

My mother walked to Sudan with a group of friends. She was young,
she was eighteen, she didn't even pack. She left to go to Sudan with only
the clothes on her back. On their way, every time they saw a soldier or
anyone, they would hide behind trees. One night after crossing the border
they were looking, amongst the trees, for a place to sleep. This is where my
parents met. My father knew about the process in Sudan for Ethiopians
to come to America. So my father got asylum and came to America with
my mother. After two months of being here, I was born.

Helen Asfaw
Ethiopia

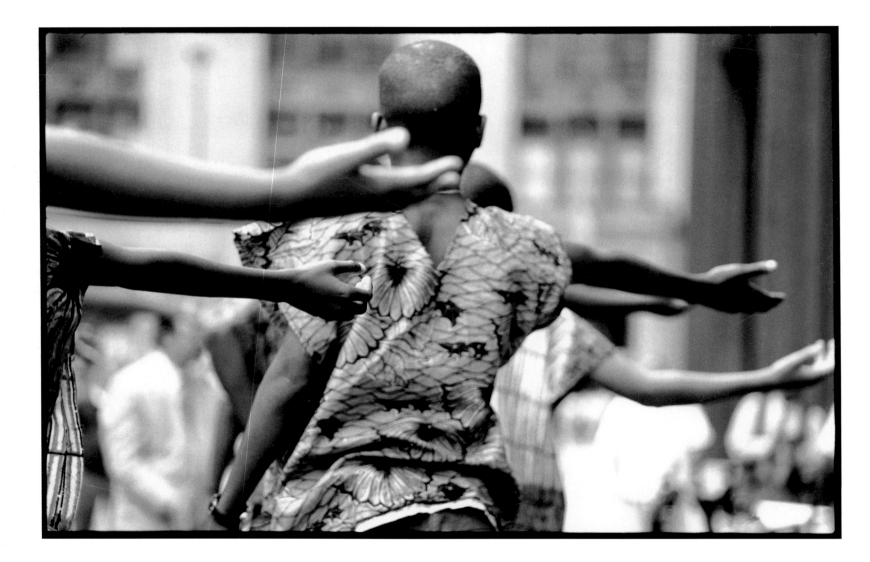

Bahamian Independence Day
Downtown Chicago, 1995

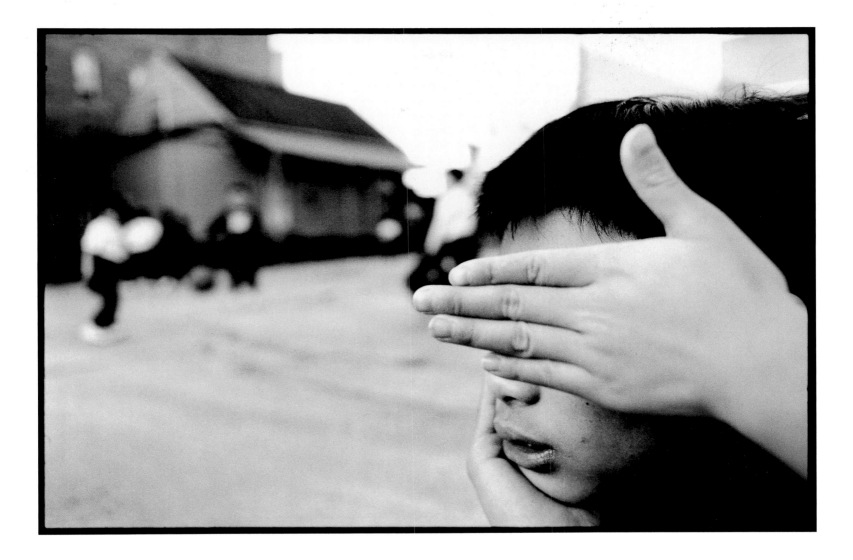

Boy on playground, St. Therese School
Chinatown, 2000

When my parents came to the United States, they came as poor immigrants. They first moved us into a studio apartment in Chicago. A month after they came I was born. When I was born, my parents thought of my future, about how to live a successful life. They thought of me as the lucky child in the family because I was the only one who was born in America.

Yoviel Gebre
Eritrea

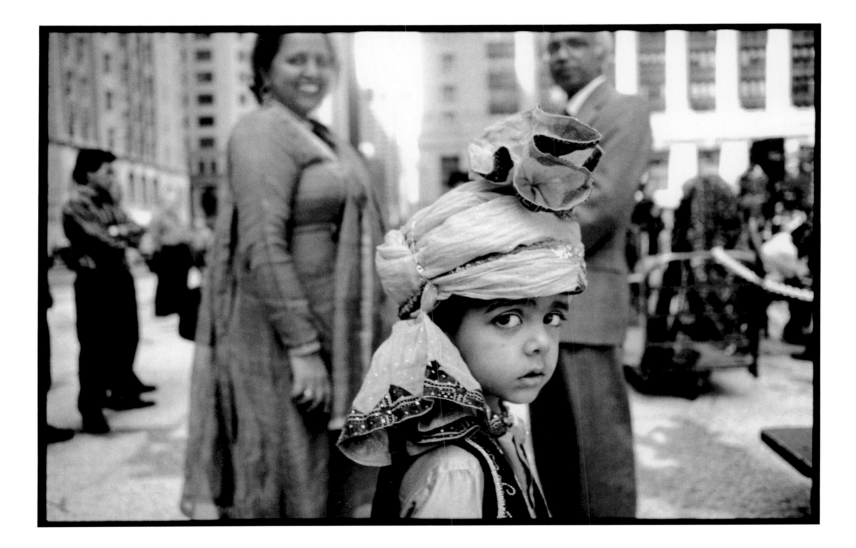

India Independence Day
Downtown Chicago, 1997

I have been in America for years now. I have gotten used to all of its surprises. When I first arrived, though, I wasn't so prepared. My senses got a whole new world to explore. I was amazed to hear so much traffic and machinery. The buildings were so modern and carefully constructed. The stores were filled with things I never saw [before]. My fingers touched the lacy material on the dresses. My nose was filled with the smells coming from different directions. Oh how I enjoyed my first day!

Khrystyna Hrinik
Lithuania

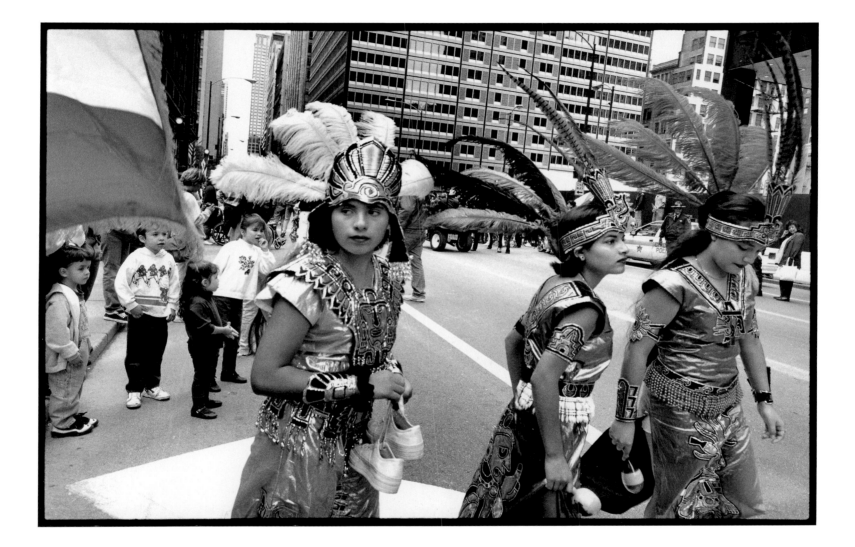

Mexican Independence Day
Downtown Chicago, 1997

This country is strange. It does have many accomplishments but there are some drawbacks. The democracy is so complicated. A good thing is that America has excellent education and medical service. Everyone is well off and can afford the basic necessities. Overall, it is a very good country. I wouldn't want to live anywhere else.

Natalia Twyniw
Poland

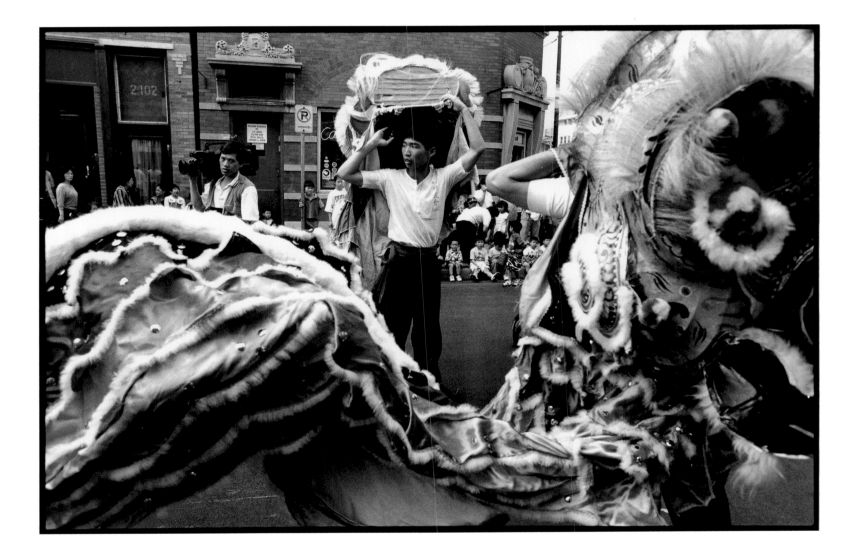

Snake dance
Chinatown, 1998

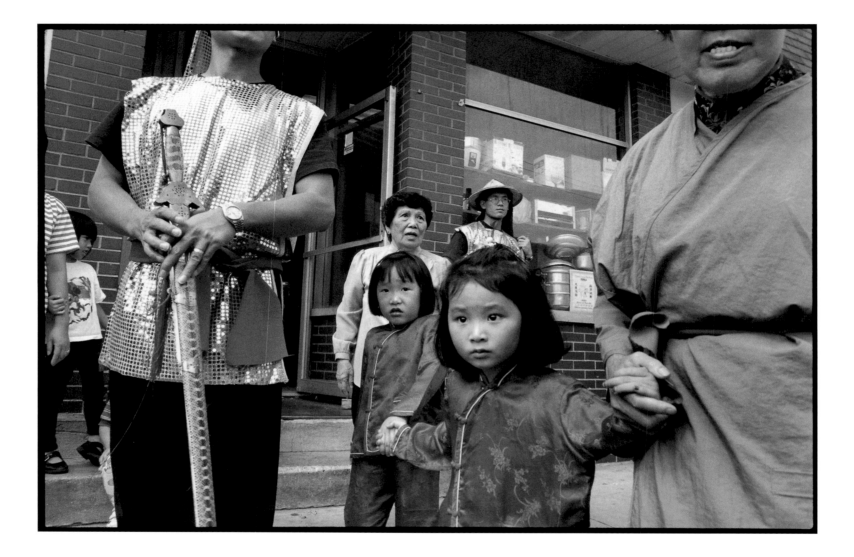

China Moon Festival
Chinatown, 1997

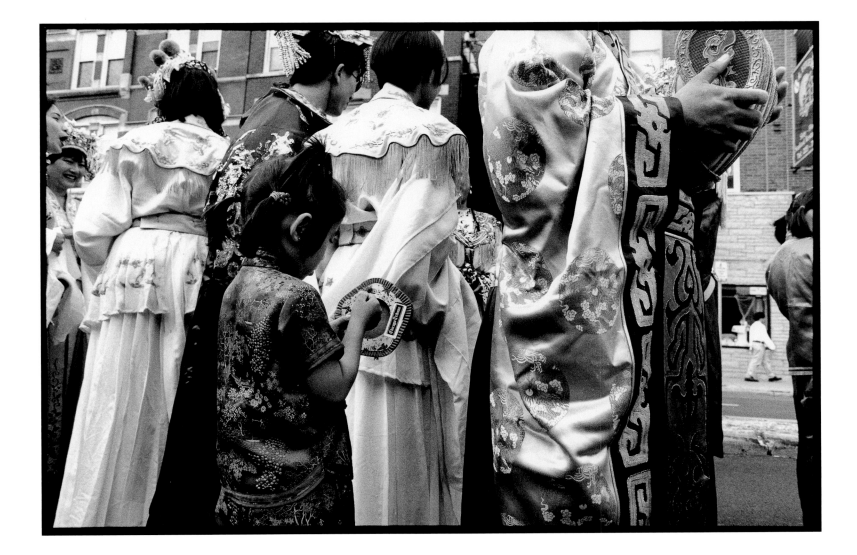

China Moon Festival
Chinatown, 1997

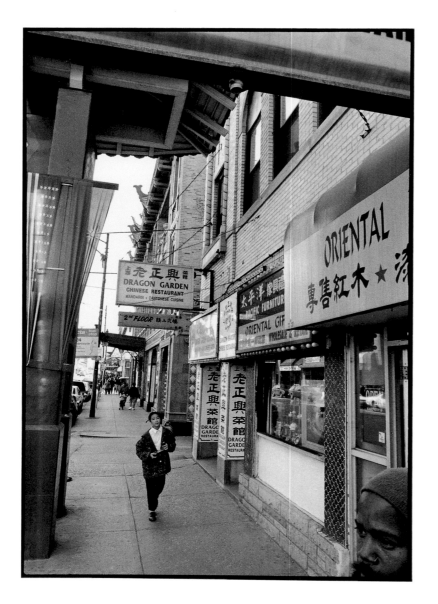

Wentworth Avenue
Chinatown, 1995

I am going to tell you how my family and I got to come to the United States of America. My dad was a veteran in the Vietnam War. He was fighting against the Communists. When the war was over, the North won. Many men, like my dad, who fought against the Communists, were sent to prisons. The United States lent us a hand by taking refugees into their own country. The majority of the refugees were veterans. Thanks to the United States I am no longer under anyone's control except my parents. I no longer have to live in poverty. I don't have to live in a house made out of palms.

Trinh Tu
Vietnam

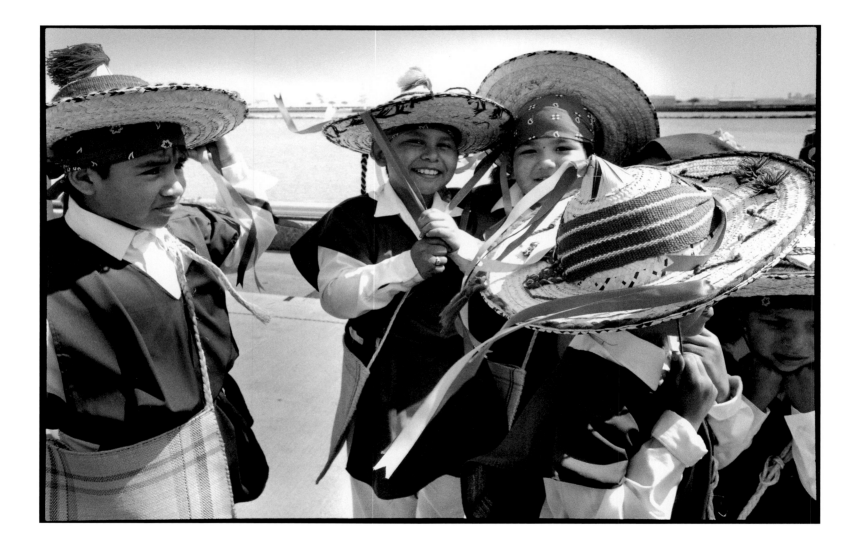

Cinco de Mayo
Navy Pier, 1996

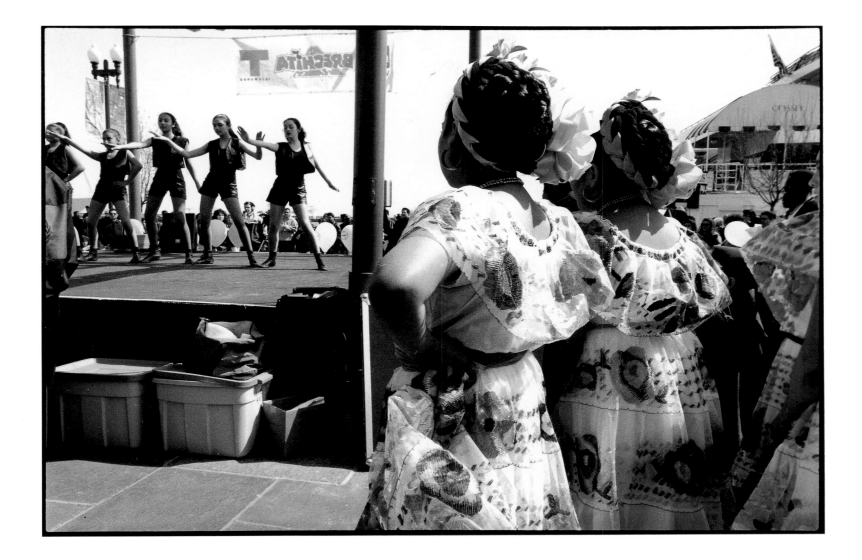

Cinco de Mayo
Navy Pier, 1997

Tolerance means being accepting and helpful to others. It's about having your opinions and listening to those of others. Tolerance is about justice. Tolerance is about being a good American in a free country.

Tobi Abegunde
Nigeria

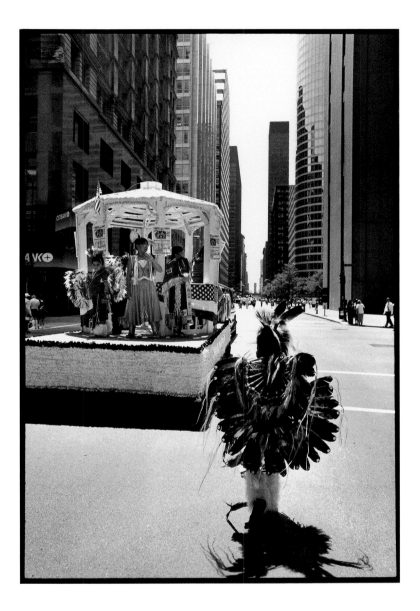

Ethnic Heritage parade
Downtown Chicago, 1999

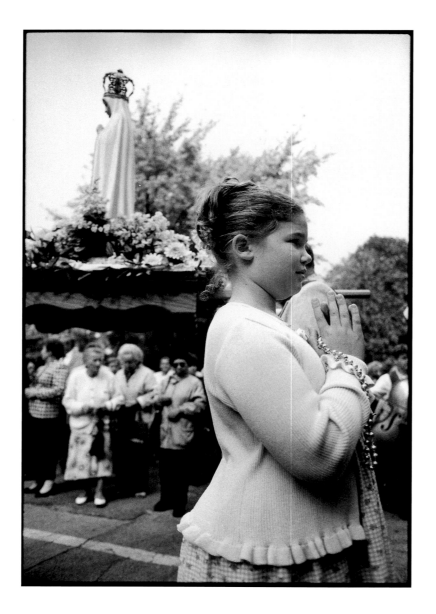

Polish procession
Ukrainian Village, 2002

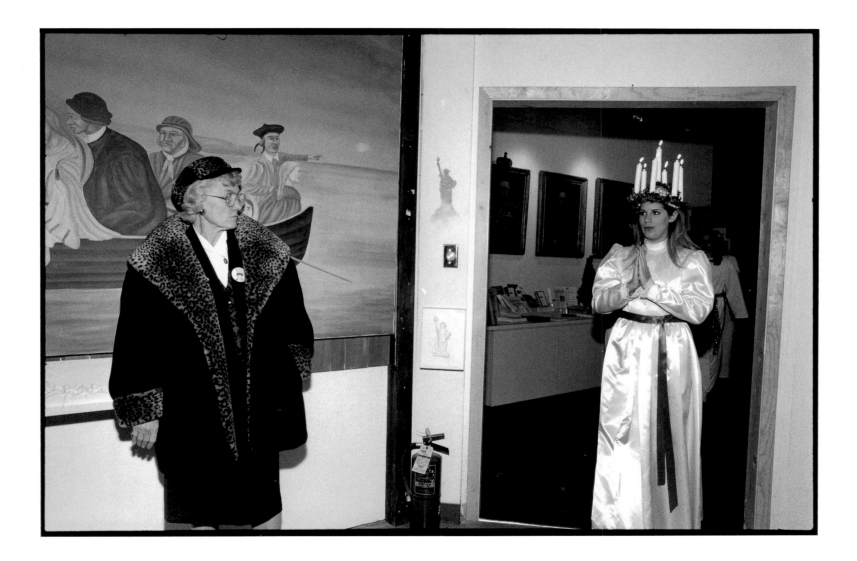

St. Lucia celebration, Swedish American Cultural Center
Andersonville, 1997

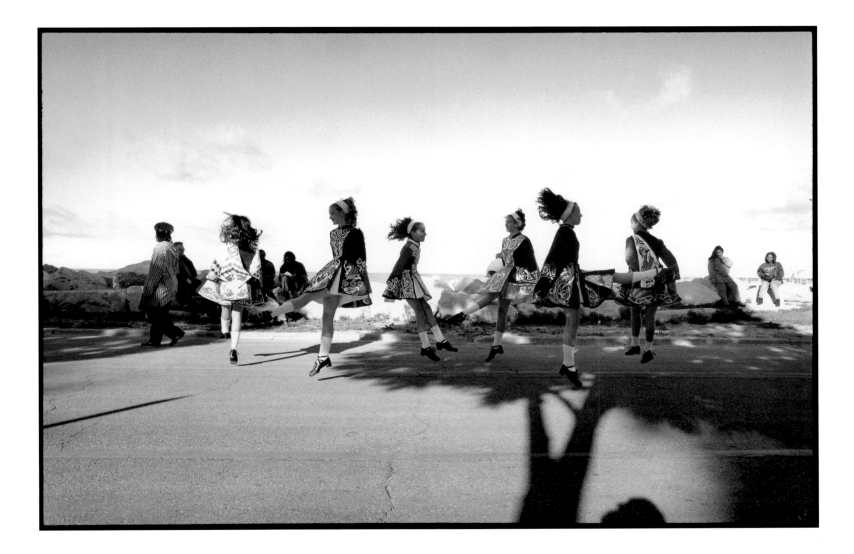

Chicago Trinity Irish Dancers
Lake Michigan, 1996

Assimilate: To make similar. To absorb and integrate into the cultural tradition or mores of a wider society or culture, population or group. To compare; to liken.

Americanize: To assimilate into American culture. To become American, as in spirit.

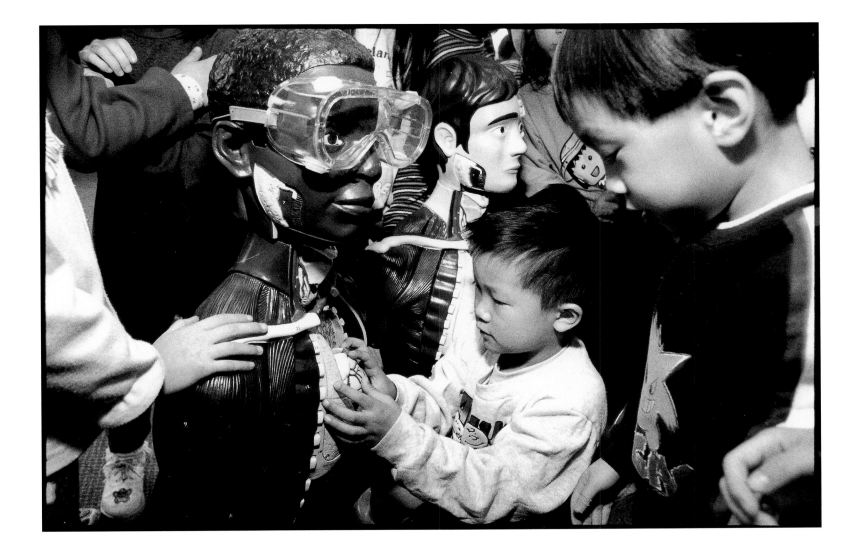

Anatomy lesson, Haines School
Chinatown, 2001

To be an American means to be free of all prejudice and oppressive cruelties, to be free of religious ridicule, to be free to be whatever you want to be!

Ruth Tekeste
Eritrea

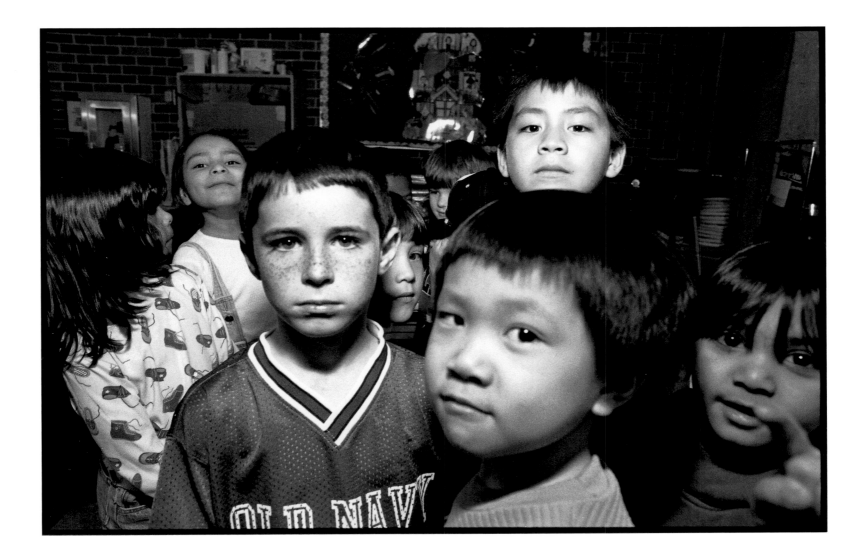

Walt Disney Magnet School
North Side, 1997

America would be a better place if we were kind and helpful to others, no matter what their sex, religion, color, or nationality. America would be a better place if we stood together as a strong country.

Haban Andemariam
Eritrea

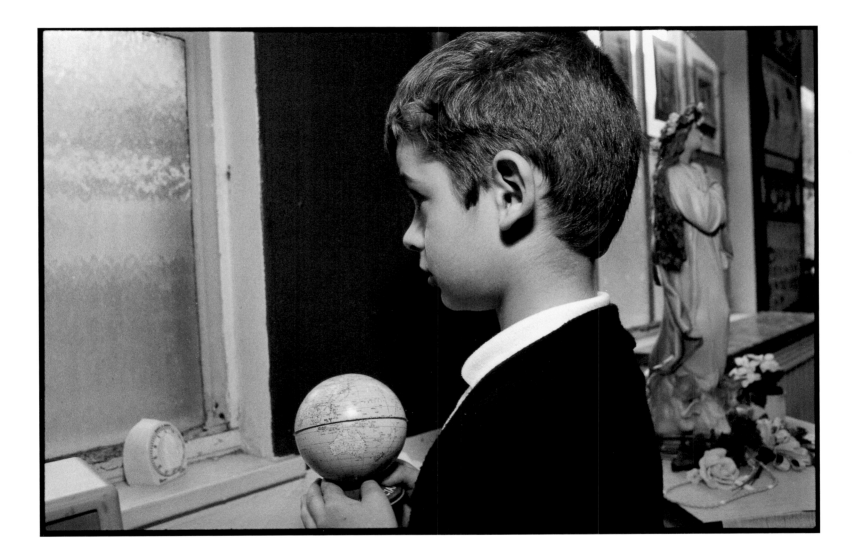

Boy from Poland, Nativity B.V.M. School
South Side, 1999

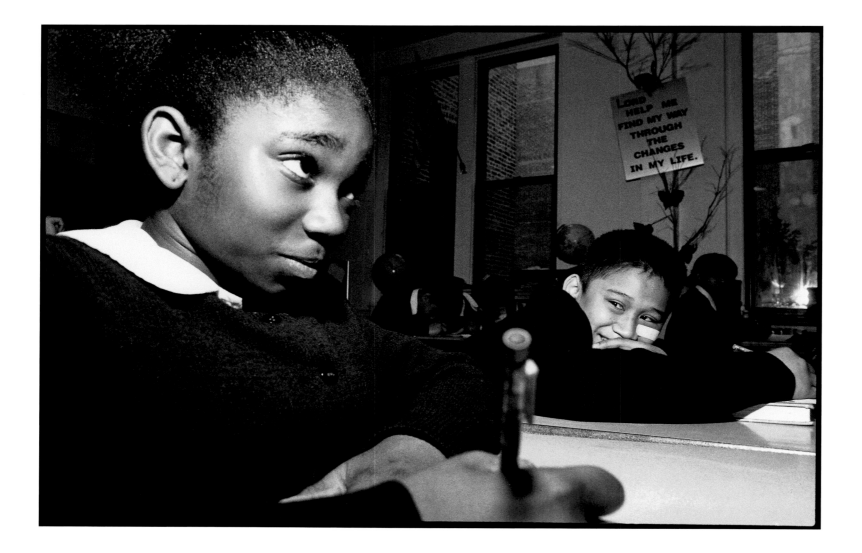

Girl from Nigeria, St. Thomas of Canterbury School
Uptown, 1999

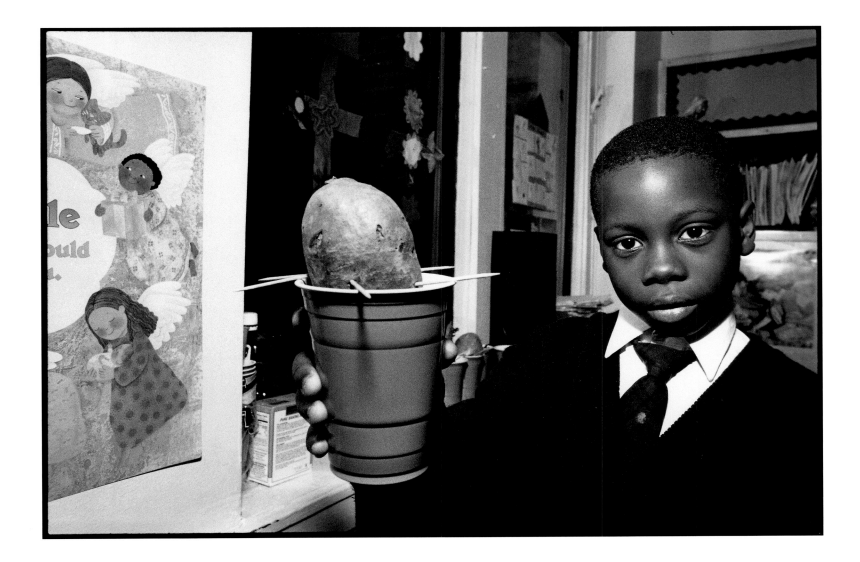

Boy from Togo, St. Thomas of Canterbury School
Uptown, 1999

The greatest thing I hope for in my life is to become a successful person and to have a family and friends to support me, not to be looked at by just the color of my skin but who I am inside.

Samira Durakovic
Yugoslavia

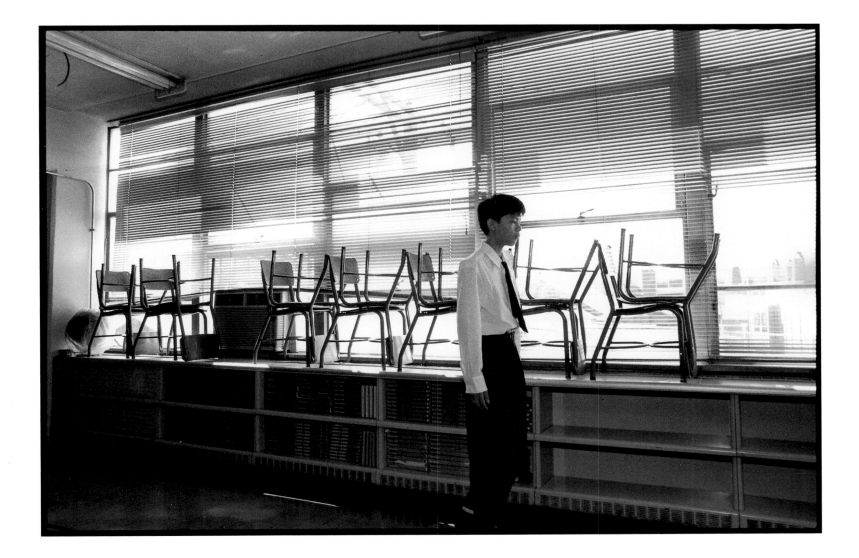

Boy from China, St. Therese School
Chinatown, 1998

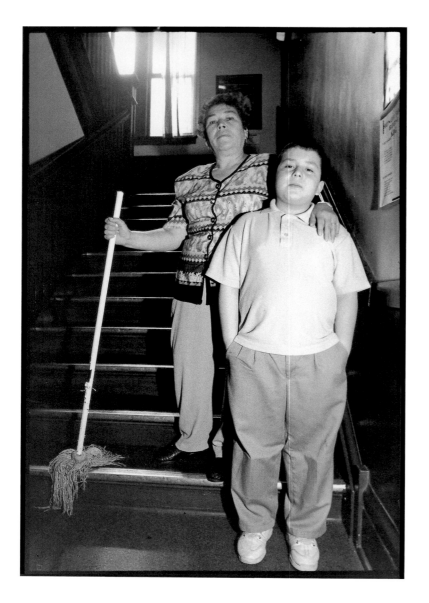

Mother and son, St. Agnes School
Little Village, 2001

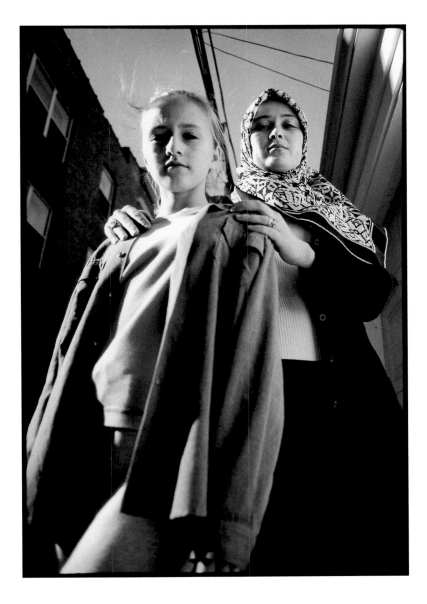

Director of Bosnian Youth Center with her niece
North Side, 2002

I had lived with my dad in Ghana and now I was living with my mom
in Chicago. I was failing some classes. I didn't understand what people
said to me. During lunchtime, I gave my food to my friends because it was
not like the food in Africa. During my first year, I thought about going back,
but when I got used to everything I never thought about going back.

Gifford Afram
Ghana

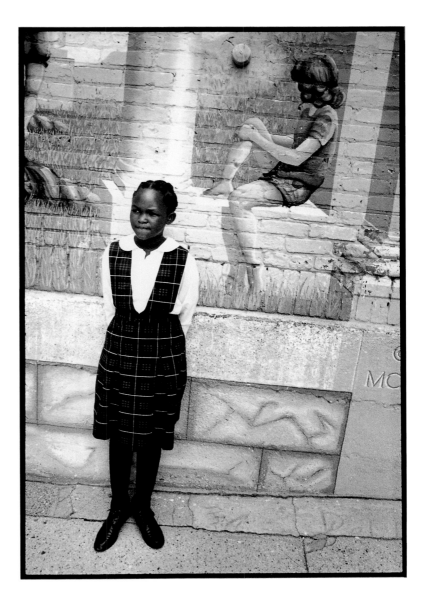

Girl from Liberia, St. Mary of the Lake School
Uptown, 2000

Citizen: A person owing loyalty to and entitled by birth or naturalization to the protection of a state or nation. An inhabitant of a city or town; especially one entitled to the rights and protection of a free person.

Citizenship: The status of being a citizen. A membership in a community. The quality of an individual's response to membership in a community.

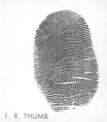

1. R. THUMB

The word "American" is so strong. I feel very protected when I am an American. In America they have laws that help and protect you.

Tommy Tang
Vietnam

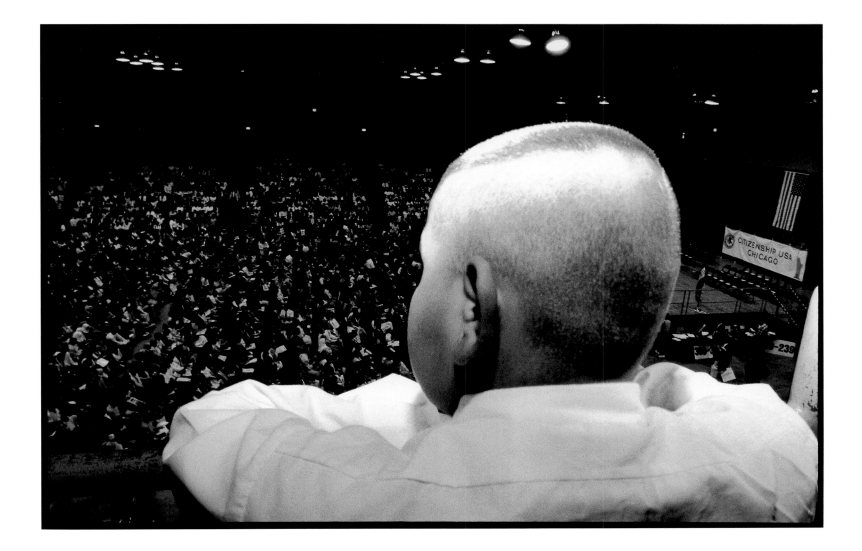

Swearing-in ceremony for 7,000 new citizens
University of Illinois at Chicago Pavilion, 1997

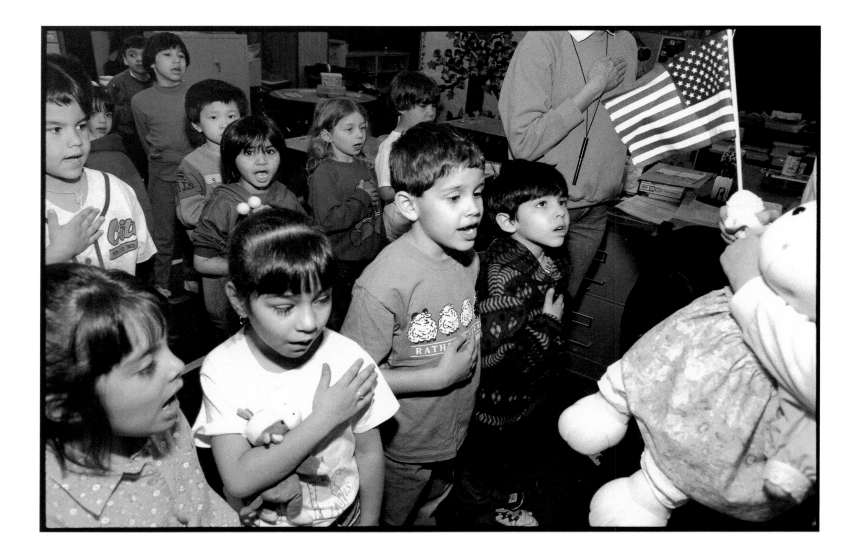

Pledge of Allegiance, Walt Disney Magnet School
North Side, 1997

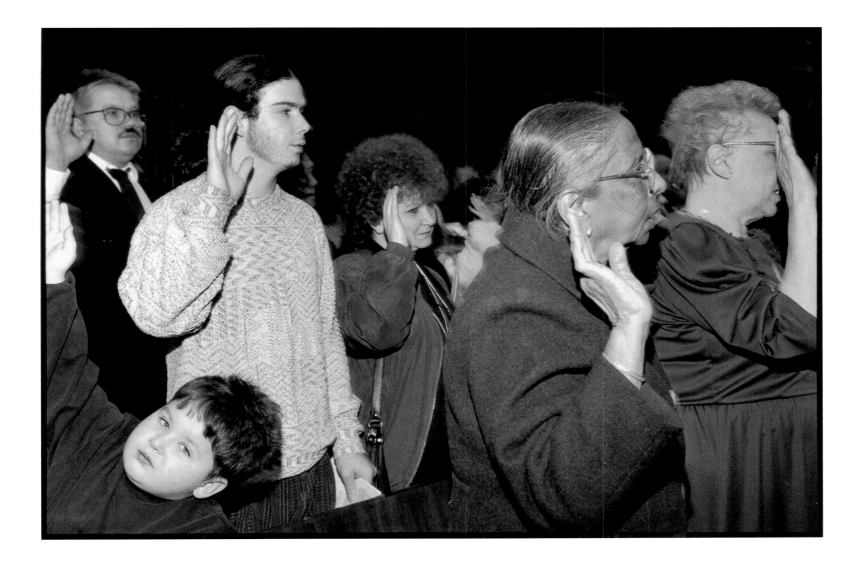

The Oath of Citizenship ceremony
Chicago courtroom, 1996

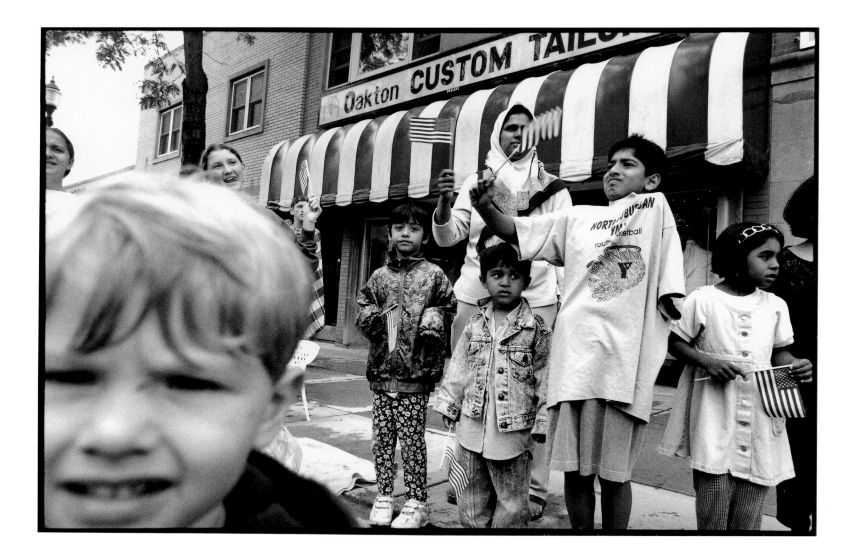

Fourth of July parade
Skokie, Illinois, 1997

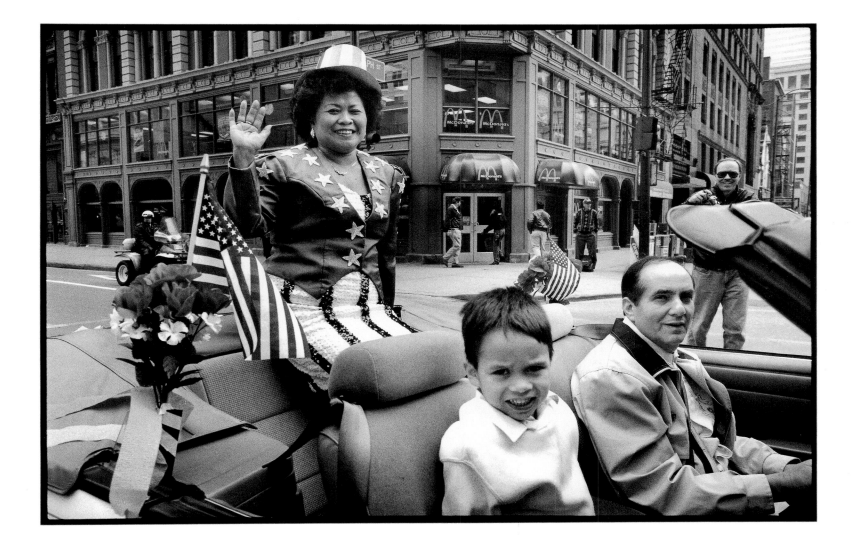

Ethnic Heritage parade
Downtown Chicago, 1995

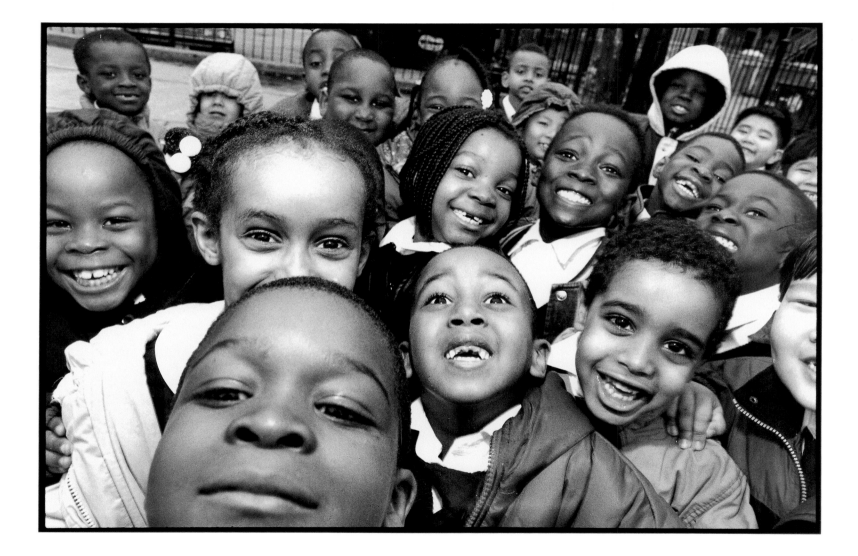

Students from Africa and Asia, St. Thomas of Canterbury School
Uptown, 1999

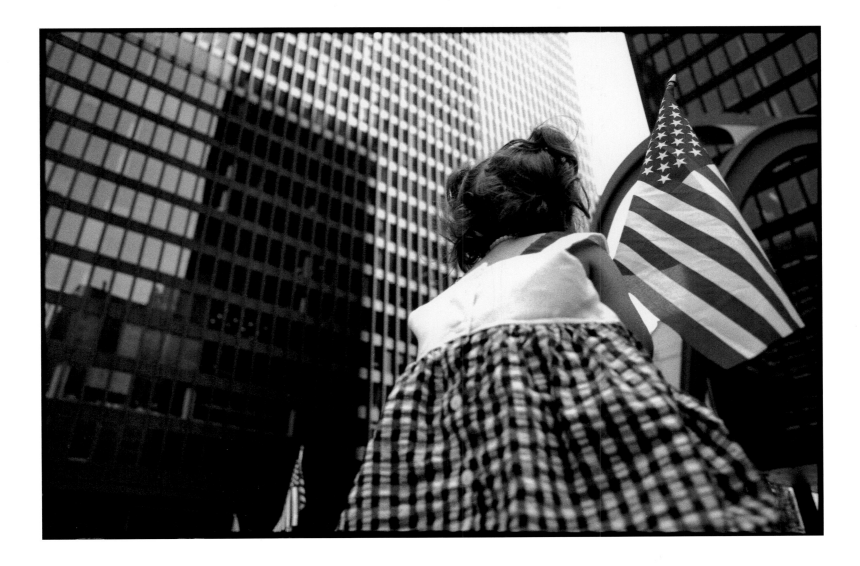

Immigration rally, Federal Building
Downtown Chicago, 1998

Home: A place where one lives: a residence, a household.
A place of origin. A place where something flourishes.
To go or return home. To move toward a goal: to home
in on the truth.

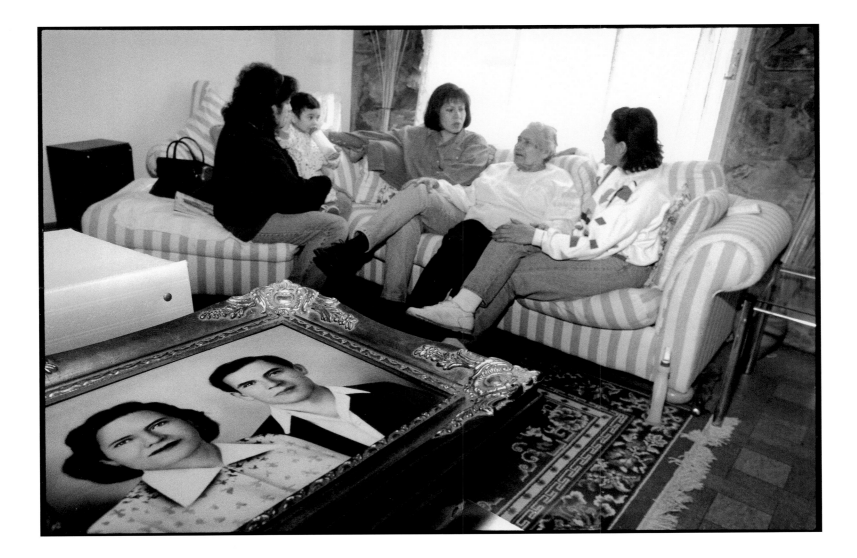

Mexican family with portrait of parents before they departed for the U.S.
Chicago, 1996

My greatest hope is to be able to make a difference in this world.
Accomplish something no one else was able to do. Live in peace
with everyone, and one day reunited with all my family members,
because my family is important to me.

Jeannette Papalotti
Romania

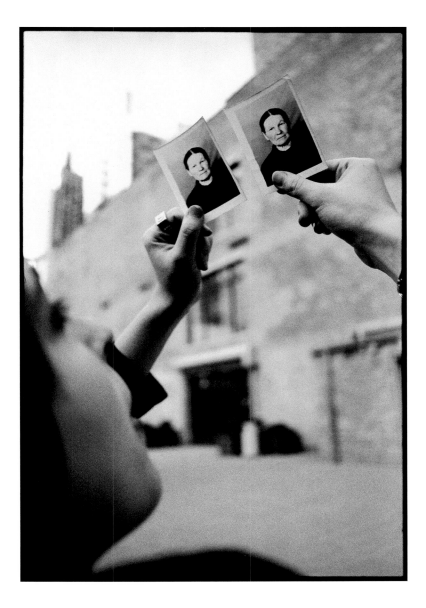

Girl with photos of her Russian grandmother
Chicago, 2002

My friend, who is also Muslim, and I were walking down a street and a man came by and murmured something under his breath. Then he looked back at us as if we were some ugly monsters walking down a street. I wish that no one was discriminated against because of their color—and that no one be in pain because of what someone has said.

Sodia Warisi
India

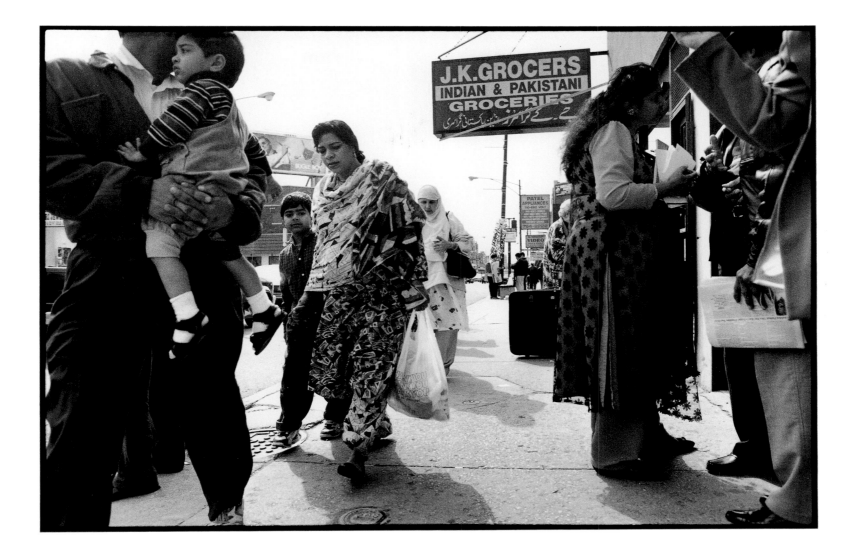

Shoppers at Devon and Western
West Rogers Park, 1997

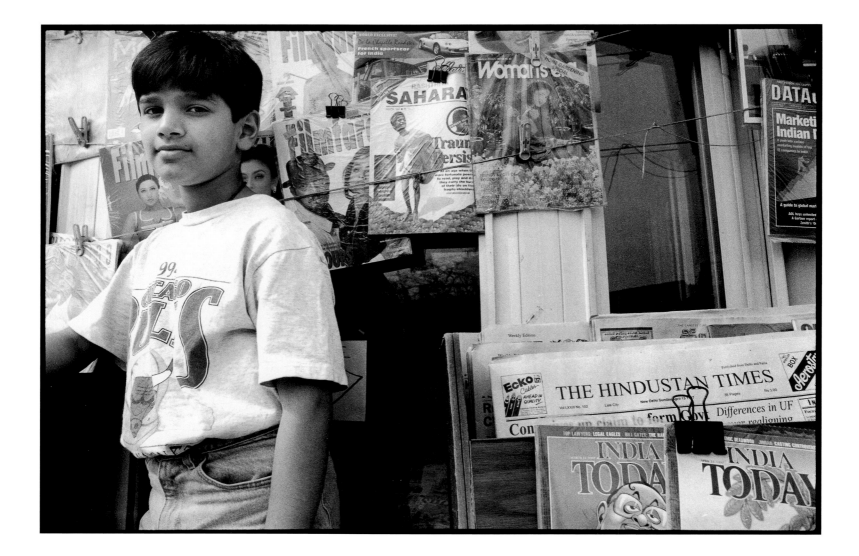

Newsstand at Devon and Western
West Rogers Park, 1998

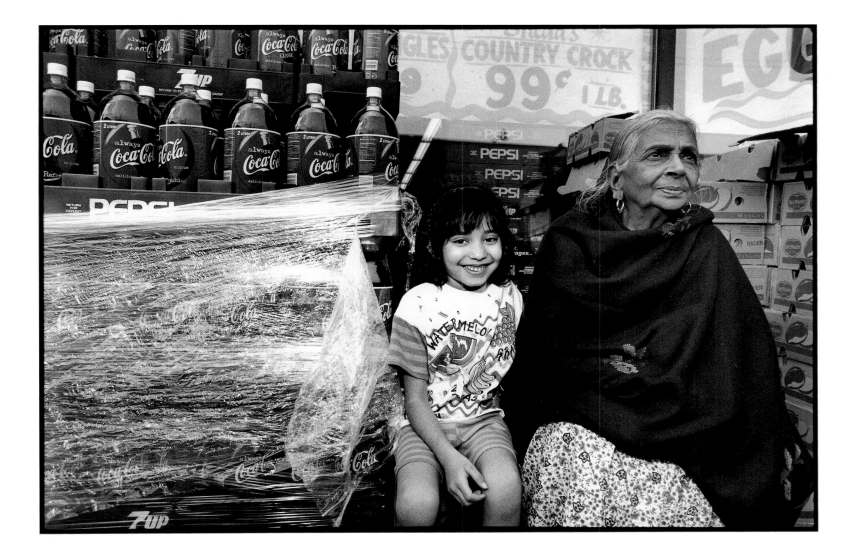

Grocery store at Devon and Western
West Rogers Park, 1998

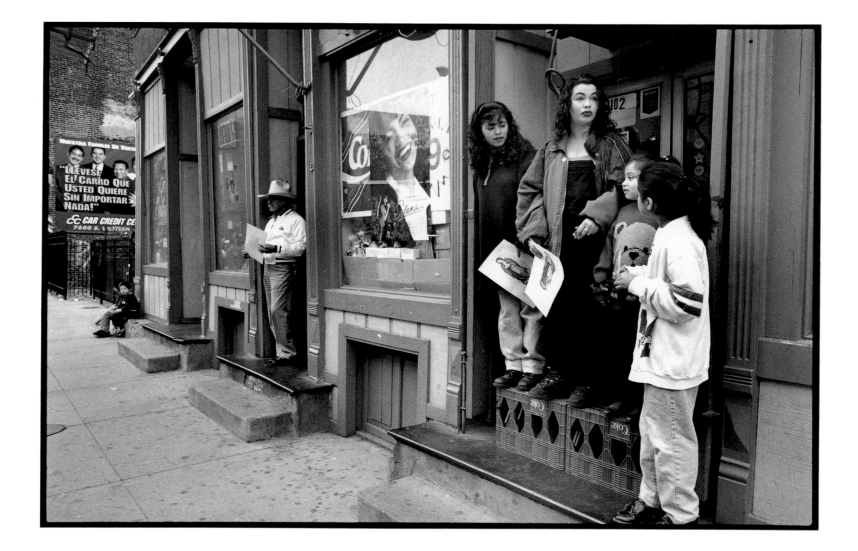

Watching a parade on Good Friday
Pilsen, 1997

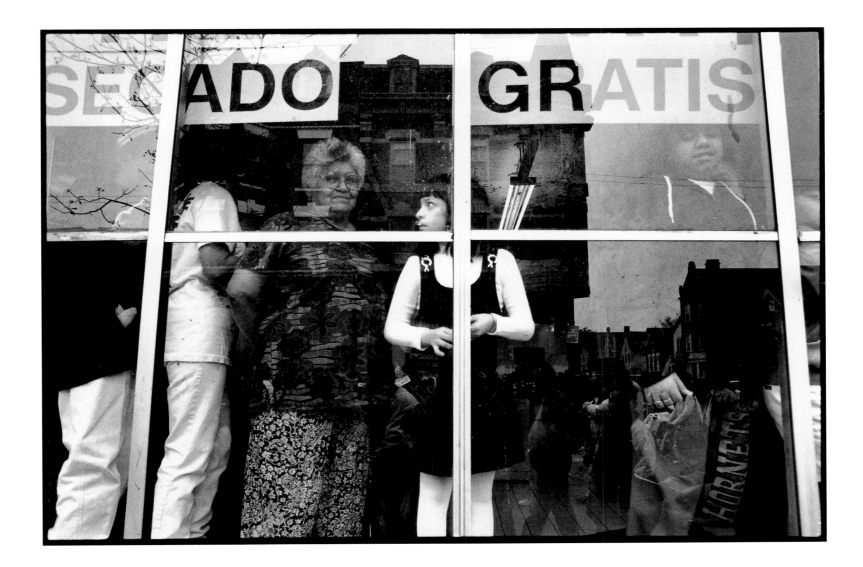

Storefront on 18th Street
Pilsen, 1997

When my father came to America from Mexico he was in his middle teens, around fifteen or so. He had come to America not only because of necessity but because he had heard so many wonderful things about it.

Diane Refanos
Mexico

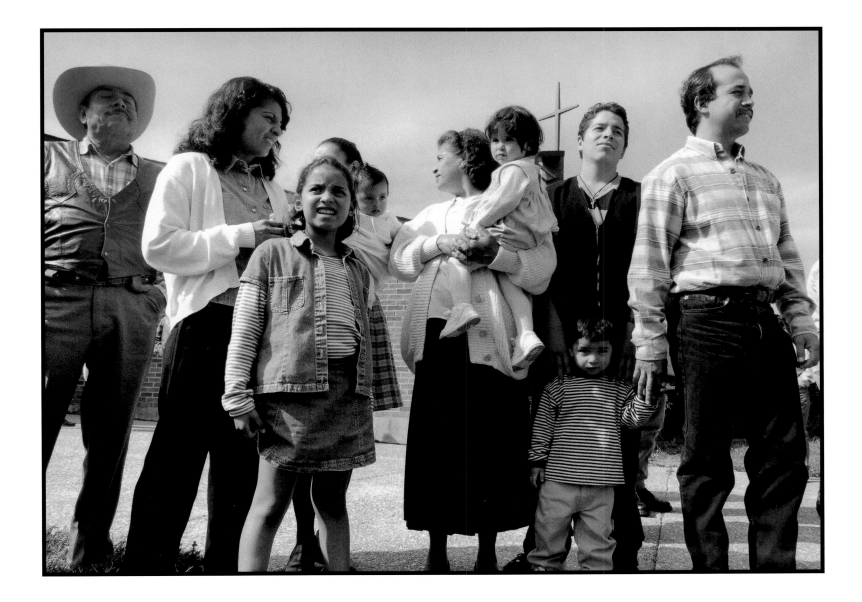

Spanish Mass
Grayslake, Illinois, 1995

Home is a place to protect my family and me. A place to sleep, eat, study, and take a bath. Also the sweetest and safest place I have ever been in.

Rasy Nhol
Cambodia

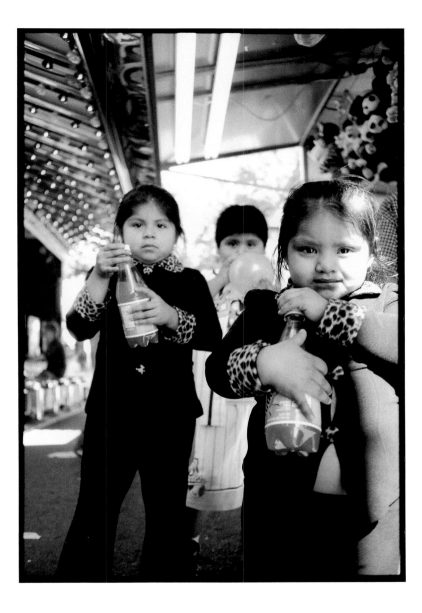

Carnival
Uptown, 2000

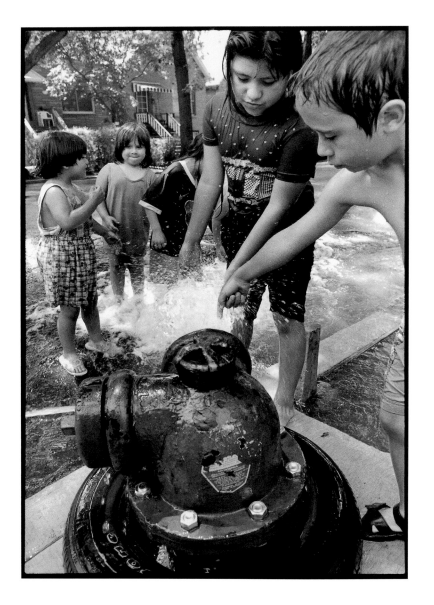

Cooling off
Humbolt Park, 1997

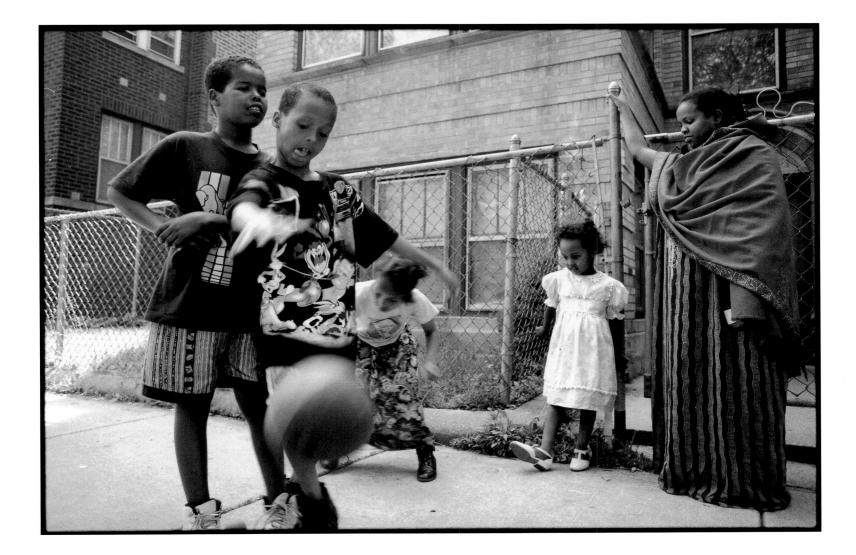

Street play
Rogers Park, 1997

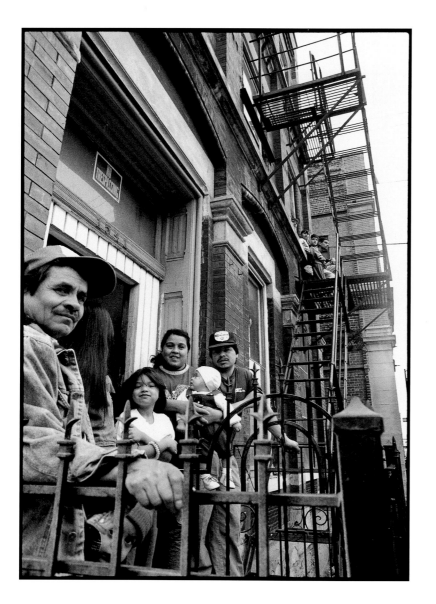

Families from Mexico
Pilsen, 1997

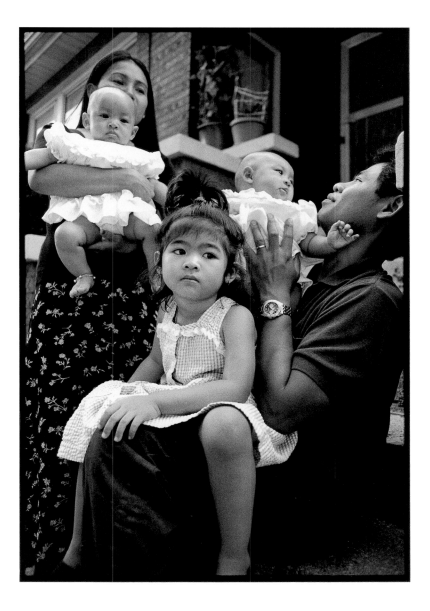

Family from Cambodia
Albany Park, 2001

I believe as an individual I can help America achieve its goals. I remember last year I helped collect canned foods for the soup kitchen. Also I raised money when the Twin Towers fell. I believe things like this may seem little but can mount to larger and bigger things.

Zainab Sozzer
Pakistan

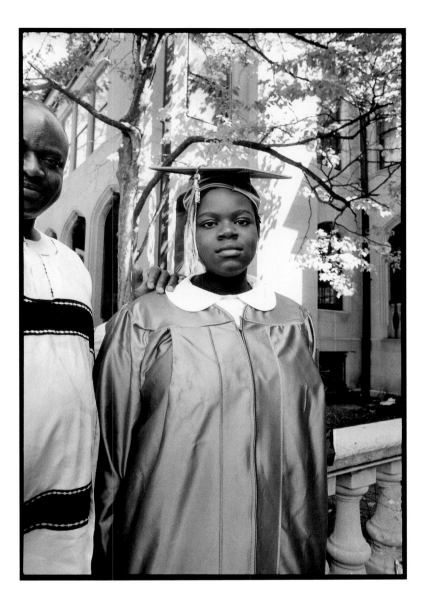

Valedictorian with her father from Nigeria, St. Thomas of Canterbury School
Uptown, 2002

Tolerance: The capacity for or the practice of recognizing and respecting the beliefs or practices of others; the ability to tolerate, or have sympathy for, behavior or opinions that one does not necessarily agree with. Endurance, fortitude, stamina.

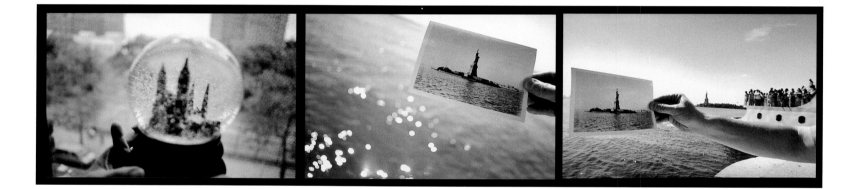

New York City, 2000

Immigration to the United States

by Leo Schelbert

IN 1964 JOHN F. KENNEDY'S PAMPHLET, with the provocative title *A Nation of Immigrants,* was re-issued as a trade paperback reprint. It signaled a sea change in American self-understanding, foreshadowed already in Franklin D. Roosevelt's serious, perhaps mischievous, admonition given to an assembly of the Daughters of the American Revolution on April 25, 1938: "Remember, remember always that all of us, and you especially, are descended from immigrants."

At its founding in 1776 the United States viewed itself as an Anglo-Saxon, Protestant, and white nation. Ethnicity, religion, and race were clearly to define its future. Amerindians were thus not to become part of the nation-in-the-making. Those indigenous peoples were allegedly incompatible with the plan in blood as well as culture.

People of African descent, toiling as laborers or artisans in fields and shops, were also tolerable only as an enslaved or at best a segregated people. They, too, were supposedly irredeemably inferior in nature as well as cultural tradition.

From the late eighteenth to the late nineteenth centuries the new nation embarked on a continental conquest, destroying, removing, or segregating into so-called reservations those of the indigenous world who had survived the onslaught. The people of African and mixed descent remained in legal bondage until 1863 and then as a segregated people deep into the mid-twentieth century. At the same time, the new nation built up its economic, social, and political institutions, inspired by the tenets of the European Enlightenment and in contradistinction to Europe's Old Order, based

on royalty and nobility. After some tentative moves toward direct democracy, a system in the form of a republic based on representation replaced kings and nobles. European industrialism—that is, mass production by machines housed in factories and served by an unskilled labor force—was vigorously adapted and further developed in building an ever-growing continental economy. Christianity, while relegated by the separation of church and state to the private domain and publicly embraced only in its Deistic understanding, was developed into new vibrant forms based on private effort. These developments set the stage onto which the foreign-born were to march over the coming centuries, becoming part and parcel of a nation which at its inception in 1776 counted some 3 million and in the year 2000 more than 281 million people.

Shifting Contexts

Adopting British policies, the new nation in the 1830s began to welcome large numbers of European arrivals. Waves of Irish, Germans, and Scan-dinavians reached the North American shores, eager to occupy the fertile lands wrested in stages from indigenous sovereignty, or to toil as artisans in towns or in the ever-larger factories being built in urban centers. The newcomers, or their sons and daughters, followed the moves generally westward into what became known as the Midwest, then on to the Pacific coast as well as the Great Plains. (The Spanish, of course, were by 1776 already well entrenched in the Southwest and much of coastal California, and the Russians were well familiar with Alaska and the Pacific Coast of the Northwest.) Trades people and unskilled laborers filled shops and factories in cities such as Baltimore, Boston, Philadelphia, and New York, Charleston, Cincinnati, and Chicago, St. Louis, New Orleans, San Francisco, and Los Angeles. While Scandinavians were Protestant in faith, numerous Germans and most Irish were staunchly Catholic. The Irish who dominated the world of labor would soon take control of the church and also of big city politics. Thus, a large segment of the newcomers threatened an initial, ardently upheld uniformity of the new nation: The

ever-expanding United States gradually ceased to be a uniform Protestant, England-derived nation. An American political party, known as the Know-Nothings, vigorously opposed what they viewed as an unfortunate trend that had to be stopped. Yet the Civil War with its nearly one million casualties tested the newcomer groups, especially the Irish and Germans who fought in great numbers for the North, as well as the South, in blood between 1861 and 1865, and gradually legitimized them as genuine Americans.

In the second half of the nineteenth century the continental conquest entered its final stage. The territory called Oregon was wrested from Great Britain in 1846 by diplomacy, the American Southwest and California from Mexico in 1848 by war, and Alaska from Russia in 1863 by purchase. The newly acquired territories needed to be settled, towns and cities to be built up, and a continental economy forged on the basis of bountiful resources.

When after the 1880s the number of arriving Western Europeans diminished, the origin of newcomers gradually shifted. Southern Italian Catholics, Eastern Orthodox Christians, and East European Jews arrived in the millions between the 1880s and 1914 when the First World War interrupted the flow, briefly, to resume in the 1920s. Now national uniformity became threatened once more not only by the arrival of immigrants from Southern and Eastern Europe, but also from Asia, especially from Southern China. Yet this latter perceived threat to white dominance was quickly and decisively dealt with: In 1882 Chinese were excluded from the American commonwealth; the few who were present could be sojourners only, and could neither become citizens nor hold property. Gradually Congress negotiated the exclusion of other Asians so that the United States would be preserved as a nation largely of European origin.

Economic need and the rise to world power status, however, superseded the threat to ethnic homogeneity deriving from the arrival of massive numbers of Southern and Eastern Europeans. On the one hand, industrialization had evolved at a rapid pace and by the 1890s the United States had not only joined, but also begun to challenge the European colonial powers, starting with weak-

ened Spain. The U.S. annexed Hawaii in 1898, Puerto Rico in 1900, and crushed fierce Philippine resistance to an American takeover of the islands by 1902.

In this new context population growth in whatever form was not only an asset, but also a necessity, yet the challenge that the new type of newcomers represented had to be met "properly." An intensive Americanization movement emerged that strove to inculcate American values and lifestyles in the newly arrived peoples of alien tongue and, also, to instill in them fervent patriotism and national pride. Immigration, furthermore, needed to be controlled, a goal achieved by quotas based on ethnic and racial origin. In the hope of salvaging some of the old dreams of ethnic uniformity, the new order, in place by the mid-1920s, privileged people from Western Europe, limited those from Southern and Eastern Europe, and maintained the exclusion of Asian people. Yet, just as the Irish and Germans had been legitimized by proving themselves in the Civil War, the post-1880s immigrants and their children were also to be tested and to become fully accepted by

service in the two world wars of the twentieth century and in two American wars waged soon after on the battlefields of Korea and Vietnam.

By 1950 the world had changed once more. The United States had emerged as the dominant world power, challenged only by the Soviet Union. India and China had freed themselves from western domination and African colonies had begun to wage a relentless and gradually successful struggle against colonialism and foreign occupation. The election of a Roman Catholic as president of the United States and his assassination in 1963, furthermore, signaled internal change and set the stage for a shift in the American legislative ordering of immigration.

Exclusionary policies seemed ever more incompatible with the ideals of the United States, especially given its new self-understanding as not only a military and political, but also a moral world leader. The Civil Rights movement, vigorously carried forward by African-American people, implicitly further exposed race-based immigration policies as contradictory to American values. Thus, the Immigration Act of 1965, passed in the shadow of John F. Kennedy's death, abolished the

exclusion of Asian peoples as well as quotas based on race or ethnicity. It set a ceiling of 170,000 visas to be issued annually for the Eastern Hemisphere and stipulated a maximum of 20,000 for any of its countries. The Western Hemisphere was allocated 120,000 annual visas, but without specific limits for individual nations. This change of immigration laws was to lead to a third great shift in the composition of newcomers to the United States, as a review of census numbers reveals.

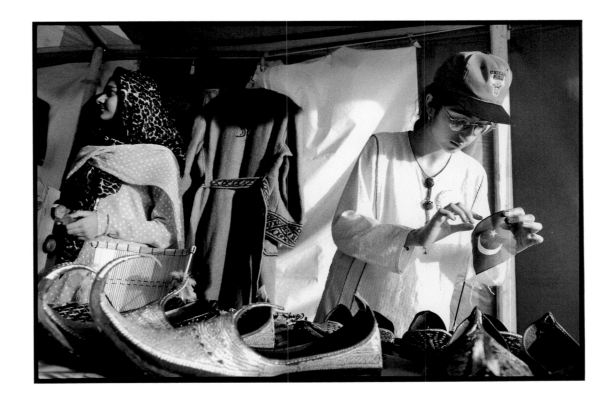

Sisters from Pakistan, Festival of Cultures
Skokie, Illinois, 1996

The Story in Numbers:
The Great Mid–Twentieth-Century Shift

The two decennial counts of 1920 and 2000 impressively document the nature of the third shift in the ethnic and racial composition of the American people as initiated by the 1965 legislation. In 1920 the U.S. census counted 13.7 million foreign-born: That is, some 14.5 percent of a population total of 107.5 million. It divided the lands of origin of the foreign-born into Europe, Asia, America, and other countries. Asia, in actuality, also meant the Middle East, since the rubric included nations such as Turkey, Armenia, Palestine, and Syria. Table 1 (see pages 108–109) lists some of the main countries from which the foreign-born had come and impressively documents the dominance of Europe (86.8 percent).

If one includes those coming from French and British Canada, Europe had provided some 95 percent of the newcomers. The dominance of Europe, especially of its western regions from which 54 percent of the foreign-born originated, is evident also from the perspective of language.

In 1920 more than 49 percent of the foreign-born and their children spoke English or German and some 24 percent other languages of Western Europe. Table 2 (see page 110), based on the U.S. census of 1920, shows the linguistic percentage distribution among the foreign-born as follows: Western Europe 73 percent, Eastern Europe 19 percent, and 8 percent for the rest of the world. Census figures for the year 2000, however, reflecting the impact of the new immigration laws of 1965, show a radically different composition of the 31.1 million foreign-born in the United States who represented 11.1 percent of its population. A summary view of their "Nativity and Region of Birth" in Table 3 (see page 111) shows the following distribution: Latin America 51.7 percent, Asia 24.3 percent, Europe 15.8 percent, and 8.2 percent for the rest of the world. Thus, in the year 2000 the foreign-born of non-European origin represented 81.4 percent of the newcomers, as opposed to 18.5 of those coming from Europe. Table 4 (see page 112) further specifies the countries of origin within each region, revealing that 29.5 percent of all foreign-born in 2000 came

from Mexico; the second largest percentage came from the Philippines at 4.4 percent.

These numbers highlight the nature of the third shift in the composition of the American people. If after the 1830s the advent of millions of Catholic Irish and Germans had transformed the Anglo-Saxon and Protestant near-uniformity of the nation into a West European and Christian one, and if after the 1880s Southern and Eastern European newcomers had changed that mainly

The Furio family at Furio's Restaurant, Grand and Odgen
River West, 1998

Western European composition into a pan-Euro-pean representation, the post-1965 era began truly to globalize the racial, ethnic, religious, and cultural mosaic of the United States. That third shift, however, will not become fully apparent for decades when numerous Americans will not be Christian, but Hindu, Muslim, Buddhist, Taoist, or Confucian; when Christian churches will be flanked by large numbers of mosques, temples, and houses of worship of non-Christian faiths; when Americans of Caucasian ancestry will have become outnumbered by those from Latin America, Africa, and Asia.

Yet, if one considers today's ancestry of Americans, those of European origin are still solidly dominant. The 1990 census had asked people to specify their ancestry, which 222.6 million did. The result, summarized in Table 5 (see page 113), yielded the following ranking: Germany #1 (58 million), Ireland #2 (38.7 million), England #3 (32.7 million), and Italy #4 (14.7 million).

It will be fascinating to compare this table of 1990, that still shows a nearly unchallenged dominance of European origins, with one that might be compiled in 2090. By that date a truly global ancestral pattern of the people of the United States might have emerged.

Enduring Experiences

While the contexts of immigration to the United States shifted over the decades and legislative responses to them reshaped the profile of the newcomers' origins, the pattern of their experiences has remained similar. If one contemplates Gina J. Grillo's telling photographs, one discovers faces filled with joy and radiant expectation, others show stoic calmness, still others reveal questioning wariness and, it seems at times, sadness. For many of the new arrivals the move into an alien world appears to be full of promise, especially if natural or humanly created disaster had driven them to seek a safer world. Others, already seasoned in facing life's unpredictable moods, seem to know that what will await them will be the usual mix of the good and the bad, of the irksome and the joyful, of trial and success. Yet other faces seem to interpret the move away from a beloved world of family, community, and village as irreparable loss. Great longing for what they had to leave behind

coupled with unease about the new surroundings, with their different tongue, lifestyle, and occasional disdain and hostility, seem to fill their souls.

In this variety of responses, the post-1965 newcomers' experience has remained similar to that of the millions who had arrived before. It is rooted not only in external circumstance, but also, and perhaps decisively, in a newcomer's personality. Thanh Tam, a young Vietnamese immigrant, explained, for instance: "I was very young when I came here. But I still remember what my house in Vietnam looked like, and the beach. One time in Des Plaines [Illinois], I was sitting by the small lake near my home. It was getting dark, the sun was orange. I sat down on a beach and closed my eyes. I saw myself on the beach in Vietnam. I started crying." When Thanh Tam's sister saw it, she inquired what was troubling her and, when told, asked in unbelief: "'Why are you still thinking of that?' Her attitude is, We're American now; we shouldn't think of the past."* Two people in the same family: One looks longingly back, the other only forward, and mutual understanding seems less than easy.

Since the nation's founding, Americans have resented as well as welcomed the foreign-born. Numerous unsung people have helped newcomers cope with the many tasks of reestablishing themselves in an alien world, thereby counteracting those who rejected the immigrants and who met them with hostility, exploitation, and occasional violence. The new arrivals themselves, neither all saints nor sinners, valiantly strove to cope with the burden of being called an alien in a foreign world and with often being pushed to the margins of society. The story will go on, if in shifting contexts. It is occurring also in numerous other nations and will eventually make the planet Earth a truly global village. Gina J. Grillo's masterful look at children of immigrants in contemporary America provides a unique perspective on the newcomers' enduring challenges.

*As quoted in Santoli, Al. *New Americans: An Oral History: Immigrants and Refugees in the U.S. Today.* New York: Viking Penguin, 1988, page 124.

Table 1: Foreign-born White Population of the United States by Selected Regions and Countries in 1920

Region	Country	Numbers	Percent
EUROPE			86.8
Northwestern			
	Great Britain	1,134,461	8.3
	Ireland	1,037,233	7.6
	Sweden	625,580	4.6
	Norway	363,862	2.7
	Denmark	189,154	1.4
	The Netherlands	131,766	1.0
	Other	346,920	2.7
		Total	28.3
Central			
	Germany	1,686,102	12.3
	Poland	1,139,978	8.3
	Austria	575,625	4.2
	Hungary	397,282	2.9
	Czechoslovakia	363,436	2.6
	Yugoslavia	169,437	1.2
		Total	31.5

Source: Adapted from Department of Commerce, *Statistical Abstract of the United States, 1922.* Forty-fifth Number (Washington, D.C.: Government Printing Office, 1923), No. 38, p. 5.

Region	Country	Numbers	Percent
EUROPE (cont)			
Eastern			
	Russia	1,400,489	10.2
	Finland	149,824	1.1
	Lithuania	135,068	1.0
	Rumania	65,920	0.7
	Bulgaria	10,477	0.1
		Total	**13.1**
Southern			
	Italy	1,610,109	11.7
	Greece	175,972	1.3
	Spain and Portugal	122,308	0.9
		Total	**13.9**
NORTH AMERICA	Canada	1,117,878	**8.1**
SOUTH AMERICA	Mexico	478,383	**3.5**
MIDDLE EAST		102,742	**0.9**
OCEANIA		67,512	**0.5**
ASIA		7,708	**0.01**

Table 2: Foreign White Stock of the United States in 1920 according to Selected Language Group, in Percent

Region	Language	Percent	Totals
Western Europe			
	English and Celtic	26.7	
	German	22.4	
			49.1
	Italian	9.2	
	Swedish	4.1	
	French	3.5	
	Norwegian	2.8	
	Spanish	2.3	
	Danish	1.3	
	Finnish	0.7	
			23.9
	TOTAL Western Europe		**73.0**
Eastern Europe			
	Polish	6.7	
	Yiddish & Hebrew	5.6	
	Russian	2.0	
	Czech	1.7	
	Slovak	1.7	
	Magyar	1.3	
			19.0
	GRAND TOTAL Europe		**92.0**

Source: Adapted from Department of Commerce, *Statistical Abstract of the United States, 1922.*
Forty-fifth Number (Washington, D.C.: Government Printing Office, 1923), No. 41, p. 6.

Table 3: Nativity and Region of Birth of the Foreign-born in 2000

Region	Numbers	Percent of Foreign-born
Latin America	16,086,974	51.7
Asia	7,540,651	24.3
Europe	4,915,557	15.8
Africa	881,300	2.8
Northern America	829,442	2.7
Middle East	658,603	2.2
Oceania	168,046	0.5

Source: Adapted from U.S. Bureau of the Census, "Census CD LF [Long Form] Profile Summary Report. Area: United States."

Table 4: Foreign-born in the United States by Selected Regions and Countries in 2000

Region	Country	Numbers	Percent
Latin America			
	Mexico	9,177,487	29.5
	El Salvador	817,336	2.6
	Colombia	509,872	1.6
	Guatemala	480,665	1.5
	Ecuador	298,626	0.9
	Honduras	282,852	0.9
	Peru	278,186	0.9
	Nicaragua	220,335	0.7
		Total	51.7
Asia			
	Philippines	1,369,070	4.4
	India	1,022,552	3.3
	China	988,857	3.2
	Korea	864,125	2.8
	Japan	347,539	1.1
	Taiwan	326,215	1.0
	Hong Kong	203,580	0.7
		Total	24.3
Europe			
	Germany	706,704	2.3
	United Kingdom	677,751	2.1
	Italy	473,338	1.5
	Poland	466,742	1.5
	Russia	340,177	1.1
	Ukraine	275,153	0.9
		Total	15.8

Source: Adapted from U.S. Bureau of the Census, "Census CD LF [Long Form]
Profile Summary Report. Area: United States."

Table 5: Ancestry of the Foreign-born Population of the United States in 1990

Ancestry	Population	Ancestry	Population
German	57,985,595	French Canadian	2,167,127
Irish	38,739,548	Welsh	2,033,893
English	32,655,779	Slovak	1,882,897
Italian	14,714,939	Danish	1,634,669
American	13,052,277	Hungarian	1,582,302
French	10,320,935	Czech	1,300,192
Polish	9,366,106	West Indies	1,155,490
Dutch	6,227,089	Portuguese	1,153,351
Scotch-Irish	5,617,773	British	1,119,154
Scottish	5,393,581	Greek	1,110,373
Swedish	4,680,863	Swiss	1,045,495

Source: Adapted from U.S. Bureau of the Census, *1990 Census of Population, Social and Economic Characteristics, United States* (Washington, D.C.: Government Printing Office, 1993), Table 26, p.26.

The Oath of Allegiance and Children's Oath of Allegiance

The Oath of Allegiance

I hereby declare, on oath,

that I absolutely and entirely renounce and abjure all allegiance and fidelity to any foreign prince, potentate, state, or sovereignty, of whom or which I have heretofore been a subject or citizen;

that I will support and defend the Constitution and the laws of the United States of America against all enemies, foreign and domestic;

that I will bear true faith and allegiance to the same;

that I will bear arms on behalf of the United States when required by the law;

that I will perform noncombatant service in the Armed Forces of the United States when required by the law;

that I will perform work of national importance under civilian direction when required by the law; and

that I take this obligation freely, without any mental reservation or purpose of evasion; so help me God.

Children's Oath of Allegiance

I will love and be true to the United States.
I will support its Constitution,
obey its flag,
and defend it against all enemies.

Attachment to the Constitution

All applicants for naturalization must be willing to support and defend the United States and its Constitution. An applicant declares "attachment" to the United States and its Constitution by taking the *Oath of Allegiance*. In fact, it is not until taking the oath at a naturalization ceremony that an applicant actually becomes a U.S. citizen. Also, a *Children's Oath of Allegiance* is used at swearing-in ceremonies involving immigrant children, for example, children adopted by U.S. parents.

Source: U.S. Department of Homeland Security, Bureau of Citizenship and Immigration Services (*www.bcis.gov*)

Acknowledgments

I N THE POEM, "Day of the Refugios," Alberto Ríos writes: ". . . Childhood itself is a kind of country, too. It's a place that's far from me now, a place I'd like to visit again." To the hundreds of immigrant children and their families who have participated in the *Between Cultures* project, a resounding *thank you* for your generosity in allowing me to create the images on these pages and for showing me once again the "country of childhood." To the students from St. Thomas of Canterbury and St. Nicholas Ukrainian schools in Chicago, my gratitude for your wisdom and openness in sharing your immigrant stories. School principals Christine Boyd and Irenea Hankewych, your gracious support and cooperation greatly facilitated this project. Sister Margaret Marie Clifford, as schools liaison at the Big Shoulders Fund, single-handedly facilitated the 'at school' portion of my photographic work, introducing me, first, to an array of inner-city schools that served large immigrant populations in Chicago and, then, in Brooklyn, New York. Thank you for your continued faith and friendship. Cathy Hagstrom, principal of the Walt Disney Magnet School, your confidence and generosity so enriched my photographs.

George F. Thompson, president and publisher of the Center For American Places, from our first meeting inspired me with his ideas. I am grateful I had such a gifted connoisseur of communication to add clarity and rhythm to my vision. George's combination of intellect and compassion makes him unique as an editor/publisher and human

being. Bob Thall was the first mentor of my photographic life, and he spent hours listening and discussing my work, helping me find my creative voice. I will always be appreciative of his support and encouragement.

Thanks also to David Skolkin who opened the creative gates and let the ideas run wild in his design of this book, which he came to with grace and energy; to Leo Schelbert for his wonderful essay and for his interest and expertise throughout this project; to Randall B. Jones at the Center for American Places for his conscientious attention to detail; to Lauren A. Marcum at the Center for her good-natured assistance; and to Jason Lazurus at Columbia College Chicago for his initial digital scanning of the images for this book. To the gifted students whose artwork inspires my own, thank you for the visual gems that introduce five of the book's six sections: Thu Pham, Justyna Nytko, Christopher Savoia, and Azmera Berhe.

Thanks to John Mulvaney who believed from the very beginning that *Between Cultures* would become a book; to Kerri McClimen for her early passion and enthusiasm for this project, and for her friendship, and also to her husband Dan and son Aidan; to the Fannie Mae Foundation, Jack Hayes, and the City of Chicago and Mayor Richard M. Daley for the unrivaled support of the Chicago Citizenship Assistance Council in first bringing *Between Cultures* to the public's attention; and to Deanna Schoss, of the Chicago Department of Aviation.

I am grateful to David Foster of the Field Museum of Natural History and to Rosa Cabrera of the Center for Cultural Understanding and Change at the Field Museum for their most enthusiastic participation; and to the outstanding staff of the Ellis Island Immigration History Museum in New York City—Cynthia Garrett, Diane Dayson, Diana Pardue, Nora Mulrooney, and George Tselos—with special thanks to Judy M. Giuriceo, who helps me keep my finger on the pulse of the most important U.S. immigrant heritage institution in our country.

A special *thank you* to the U.S. Department of Justice, Immigration and Naturalization Service; to Deputy District Director Brian R. Perryman for his generosity and openness to my work; to

Assistant District Director of Inspections at O'Hare International Airport Ori H. DiCristofaro and to Peter Mano who, along with a crew of exceptional customs officers, helped facilitate my work on new immigrant arrivals and inspired me with gratitude and respect; and to INS Public Affairs Officers Marilu Cabrera and Gail Montenegro for their diligent efficiency and for providing such energetic assistance.

I am privileged to have the friendship and support of so many colleagues, and extend my gratitude to Alan Jaffe, Peter Thompson, Lynn Sloan, Tim Long, Stephen Marc, Helena Chapellin Wilson, Susan Youdovin, Susan Soble, Linda Bubon, Steven Stajkowski, Bruno Coltri, Eileen and David Miller-Girson, Nancy Fewkes, and Varouj Kokusian, all of whom have lent their energies to this undertaking. Susan Coolen is a kindred spirit and brilliant friend who provided hours of creative conversation. My gratitude goes to Marianne Shore and her husband Dan Shore, who supplied me with my first 35-mm camera. Catherine Edelman, a force for photography and photographers in Chicago, made a simple statement to me at my M.F.A. show that gave me great encouragement. My friends, colleagues, and fellow photographers at Columbia College Chicago constantly offer their ideas and inspiration, and my students keep me close to my beginnings and to what I have always loved about photography. For the support of the College, my gratitude goes to Dr. Warrick Carter, President; Steven Kapelke, Provost; Michael DeSalle, Vice President of Finance; and Leonard Lehrer, Dean of Fine and Performing Arts. I also thank Rod Slemmons, Director, and Natasha Egan, Assistant Director, of the Museum of Contemporary Photography for their valued feedback and advice, and also to Stephanie Conaway, Karen Irvine, Corrine Rose, and Deborah Peterson.

The publication of *Between Cultures* was made possible by generous contributions from Columbia College Chicago, the Graham Foundation for Advanced Studies in the Fine Arts, and from friends and donors Jack Jaffe, Dolores Kohl, Susan Soble, and Susan Youdovin, for which I am eternally grateful.

To my sister, Maria, brother, Robert, and my brother-in-law, Chuck Kratz, thank you for your love.

Finally, I dedicate this book to my mother, Elisa Grillo, for her love and unceasing support of my creative life; in loving memory of my father, Michael Grillo, who left me with a blueprint for pursuing a dream; and in honor of my grandparents, Diamonte and Olga, Virginia and Joseph.

Special Credits

The definitions that appear in *The Plates* section are derived from *Easton's Bible Dictionary* (1897), *Merriam-Webster's Collegiate Dictionary, Tenth Edition* (2002), and *The Oxford American College Dictionary* (2002). The color drawings that appear opposite those definitions are by Thu Pham (*Journey/Arrival*), Justyna Nytko (*Identity*), Christopher Savoia (*Assimilate/Americanize* and *Tolerance*), and Azmera Berhe (*Home*); the thumbprint (*Citizen/Citizenship*) remains anonymous.

About the Author and the Essayist

Gina J. Grillo was born in Lake Forest, Illinois, in 1960 and was raised in Lake Bluff, Illinois. She received her B.S. in business with a major in marketing from Eastern Illinois University in 1984. While working for the Chicago Council on Foreign Relations she continued undergraduate coursework in cultural anthropology at Northwestern University and in Italian language and culture at the Graham School of the University of Chicago, before studying photography at the School of the Art Institute of Chicago and then completing her M.F.A. in photography at Columbia College Chicago in 1998. Her photographs have become part of numerous collections, including those of the University of Chicago, Fannie Mae Foundation, and Albert and Tipper Gore, and she has had solo exhibitions at O'Hare International Airport, the Field Museum of Natural History in Chicago, the Children's Immigration Museum of Chicago, and the Ellis Island Immigration History Museum and Statue of Liberty Monument in New York City. Her photographs have appeared in magazines and newspapers worldwide, with photo essays in the *Chicago Tribune Sunday Magazine*, *Migration World*, *Family Support*, *Interiors*, and *New World Publications*. She continues to expand photographic opportunities for youth in communities underserved by the arts, partnering with Chicago's Multi-cultural Youth Project, Gallery 37, the Terra Museum of American Art, the Field Museum's Department of Cultural Understanding

and Change, and the Human Relations Commission of Illinois. Ms. Grillo's work is "inspired by community," as represented by her creation of a permanent photographic installation for the pediatrics wing of Trinity Chicago Hospital on Chicago's South Side. Since 1997, Ms. Grillo has taught photography as an adjunct faculty member in the photography department of Columbia College Chicago. She resides in Chicago, Illinois.

Leo Schelbert was born in Katbrunn, Switzerland, in 1929. He received his M.A. in history from Fordham University in 1960 and completed his Ph.D. in history at Columbia University in 1966. He joined the faculty of the University of Illinois at Chicago in 1971, and was a professor of history from 1979 to his retirement in 1999. He has written widely on the migration history of German-speaking people, including fifty articles and twenty chapters in such works as *Harvard Encyclopedia of American Ethnic Groups*, *Encyclopedia of Diasporas*, *Encyclopedia of the Midwest*, and *Gale Encyclopedia of Multicultural America*. He is the author and editor of nine books, among them *America Experienced: Eighteenth and Nineteenth Century Accounts of Swiss Immigrants* (1996), *Switzerland and the United States* (1991), and *Swiss Migration to America: The Swiss Mennonites* (1980). Professor Schelbert resides in Evanston, Illinois.

CENTER FOR AMERICAN PLACES

The Center for American Places is a tax-exempt 501(c)(3) nonprofit organization, founded in 1990, whose educational mission is to enhance the public's understanding of, appreciation for, and affection for the natural and built environment. Underpinning this mission is the belief that books provide an indispensable foundation for comprehending—and caring for—the places where we live, work, and explore. Books live. Books endure. Books make a difference. Books are gifts to civilization.

With offices in New Mexico and Virginia, Center editors bring to publication 20–25 books per year under the Center's own imprint or in association with publishing partners. The Center is also engaged in numerous other programs that emphasize the interpretation of *place* through art, literature, scholarship, exhibitions, curriculum development, and field research. The Center's Cotton Mather Library in Arthur, Nebraska, its Martha A. Strawn Photographic Library in Davidson, North Carolina, and a ten-acre reserve along the Santa Fe River in Florida are available as retreats upon request. The Center is also affiliated with the Rocky Mountain Land Library in Denver, Colorado.

The Center strives every day to make a difference through books, research, and education. For more information, please send inquiries to P.O. Box 23225, Santa Fe, NM 87502, U.S.A., or visit the Center's Website (www.americanplaces.org).

About the Book

The text for *Between Cultures*: *Children of Immigrants in America* was set in Sabon. The paper is acid-free Leykam, 150 gsm weight. The duotone and four-color separations, printing, and binding were professionally rendered by CS Graphics, of Singapore. *Between Cultures* was published in association with the photography department at Columbia College Chicago. Columbia's photography program is the nation's largest and one of the nation's most prestigious. For more information, go on line at: www.colum.edu/undergraduate/photo.

FOR THE CENTER FOR AMERICAN PLACES:

George F. Thompson, President and Publisher

Randall B. Jones, Associate Editorial Director

Lauren A. Marcum, Assistant Editor

Alison Drew Hunt, Chelsea Miller Goin Intern

David Skolkin, Designer and Production Coordinator

FOR COLUMBIA COLLEGE CHICAGO:

Christine DiThomas, Manuscript Editor

Jason Lazurus, Digital Scans

Bob Thall, Chairman, Photography Department